IMAGES of America

FAIRMONT'S CEMETERIES

ON THE COVER: On Sunday, September 11, 1927, a new monument to Col. Zackquill Morgan was unveiled at the Prickett's Fort cemetery. The children in Colonial dress took part in the day's program. They are all direct descendents of Zackquill Morgan. The project was headed up by the Maj. William L. Haymond Chapter of the Daughters of the American Revolution. Included on the program that day was assistant prosecuting attorney M. Earle Morgan. (Courtesy of West Virginia and Regional History Collection, West Virginia University [WVU].)

IMAGES
of America

FAIRMONT'S
CEMETERIES

Gena D. Wagaman

ARCADIA
PUBLISHING

Published by Arcadia Publishing
Charleston SC, Chicago IL, Portsmouth NH, San Francisco CA

Printed in the United States of America

Library of Congress Catalog Card Number: 2006938608

For all general information contact Arcadia Publishing at:
Telephone 843-853-2070
Fax 843-853-0044
E-mail sales@arcadiapublishing.com
For customer service and orders:
Toll-Free 1-888-313-2665

Visit us on the Internet at www.arcadiapublishing.com

This book is dedicated to Robert Allen, a former Fairmont city councilman whose vision and desire to regain the history of his community started me down this road.

CONTENTS

ACKNOWLEDGMENTS

I undertook this project as a sole proprietor. Along the way, however, I soon found the need for many helpers. Chief among them was Dora Kay Grubb, who answered my call for help by connecting me with folks around town who might have what I needed. Diane Hutchinson Parker was generous in her support of the project and furnished many of the photographs of her family and her family's castle, Sonnencroft. Jonathan Watson let me comb through his collection of photographs, postcards, and memorabilia to add substance to my content.

Melissa May of Prickett's Fort allowed the use of photographs from the fort's collection.

Blackwood Associates generously lent their postcard collection for scanning and inclusion in this book. Thanks to Jim Blackwood and Kitty Blackwell for their generosity and patience.

The Marion County Historical Society was very generous in allowing me to use its archives. Tom Kuhn and Dr. JoAnn Lough lent their keen eyes and diligent oversight to be sure I got all my facts straight. Royal Watts brought me John Champe.

Without the help of these lifetime Fairmonters, I would just be the new kid on the block who knows nothing about their hometown. Thanks to them, it is now my hometown too.

INTRODUCTION

This is not meant to be an all-inclusive look at every cemetery in and around Fairmont, West Virginia. Rather it is a look at a chronological timeline through selected cemeteries to tell the story of Fairmont's history. By recovering the history of the individuals interred in small, forgotten cemeteries sprinkled across the landscape, the history of our country and its place in world events can also be recovered. By pursuing such an undertaking, we will broaden our scope and deepen our knowledge of our sense of self and the true diversity needed to bring us where we are today. I hope you enjoy the journey as I did.

One

THO' SOFT YOU
TREAD ABOVE ME

Death is a part of life. Every culture has dealt with the need to dispose of human remains, and each has chosen a unique way of doing so. Whether someone is sent on the journey to the other side with all the accoutrements needed to make the trip or is buried in their "Sunday best" is dependent on time, place, religion, and cultural mores. Exposure, mummification, cremation, and burial under dirt or stone all are ways humans have honored their dead. In early-21st-century, postmodernist America, cemeteries are the way to go. Land set aside for the express purpose of burying the dead, cemeteries are much more. How, why, and where the dead are buried is predicated on religious beliefs and sanitation department issues.

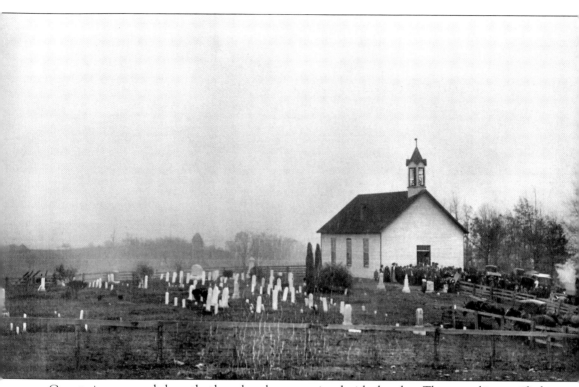

Cemeteries are sacred places that have long been associated with churches. The ground is sanctified and may only accept the mortal remains of those whose souls have been saved. Anyone whose actions in life are not sanctioned by any given church will not be given space within its fold. As cities grew and the numbers of residents far outstripped the confines of the urban churchyard, burial grounds and burying ceremonies became more commercialized. (Courtesy of the Marion County Historical Society.)

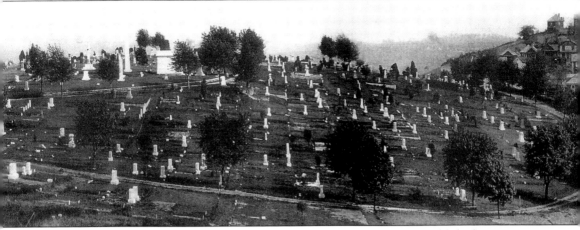

Beginning in the mid- to late 19th century, the rural cemetery movement established cemeteries outside urban areas, laying them out like parks and encouraging visits with deceased relatives and picnics. This is a view of Woodlawn Cemetery taken in the late 19th century. Although the cemetery would not have a planned landscape until the 1920s, this view shows the winding roadways, lush foliage, and tranquil setting that became valued in cemeteries. The tall obelisk to the left of center is that of Gov. Aretas Brooks Fleming. (Courtesy of Diane Hutchinson Parker.)

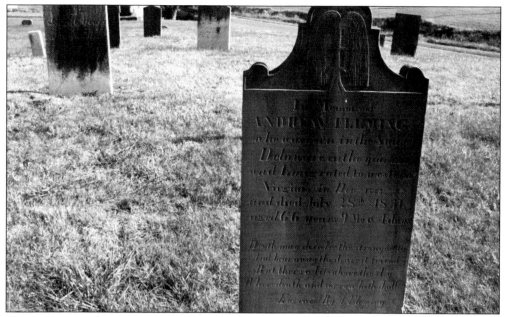

Cemeteries are also repositories of history. This stone details Andrew Fleming's move from Delaware to Virginia in 1788. The iconic image of a weeping willow attests to the family's grief. The stonecutter adds an additional element to the value of this stone. Allison Fleming, Andrew's great nephew by marriage, was a master marble cutter, and examples of his work can be found in four of the cemeteries profiled. (Photograph taken by the author.)

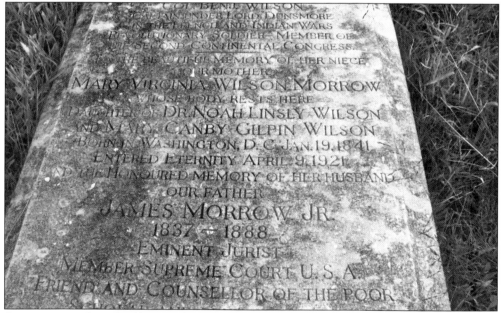

Cemeteries are also valued by genealogists. This table stone details the lives and accomplishments of several generations of one family. Begin with the name and dates on a stone, a place of origin or death, and perhaps a relationship detail such as wife, husband, or child. Record that information, and go to the county courthouse. Those crumbs of information can lead to a cache of data that can lead back several generations. (Photograph taken by the author.)

Statuary used as grave markers makes the cemetery an outdoor art gallery. Angels, doves, lambs, and flowers are all things that can be found in a cemetery. (Photograph taken by the author.)

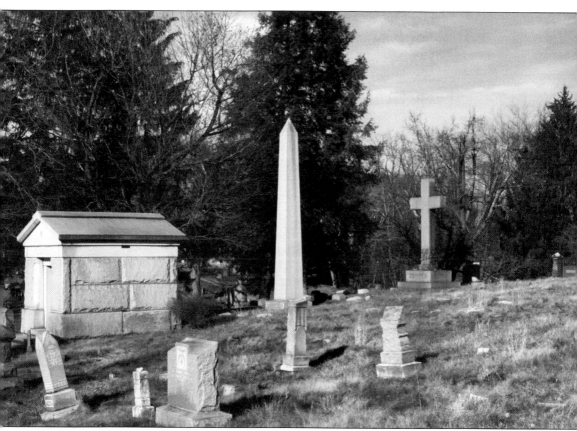

This is an interesting grouping of architectural forms. Was this planned, or is it a fortuitous happenstance? Given the men's social position, economic well being, and the fact that all three guided the growth the city of Fairmont and the state of West Virginia politically, socially, and economically, the former is more likely than the latter. The Sylvanus Lamb Watson Mausoleum in the foreground is built in a neoclassical style, while the obelisk of Gov. A. B. Fleming harks back to the Egyptian culture. The oversized cross of James Edwin Watson has lilies carved around its base and balances the height and breadth of the other two monuments. (Photograph taken by the author.)

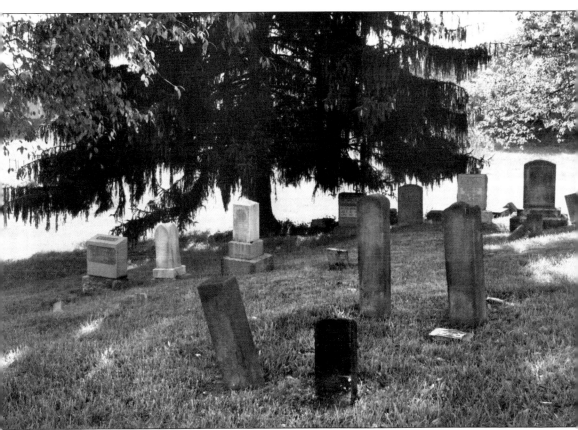

Morgan Morgan is credited with being the first European settler in what is today Berkeley Springs, West Virginia. His son Zackquill Morgan is credited with the founding of Morgan's Town (Morgantown), West Virginia. Zackquill's older brother, David, is credited with being among the early European settlers in the Fairmont area. This cemetery holds the remains of David Morgan, his spouse, and their descendants. Located on the old Morgan homestead just outside of Rivesville, about 6 miles north of Fairmont, the stones in the lower right front corner of the second row mark the graves of David Morgan and his wife, Sarah, to the left. The slightly smaller stones in front are footstones. These are placed to mark the end of the grave. To the left are the unmarked graves of their son, Stephen, and his spouse, Sarah Somerville. In the second row are grandson Henry, his wife Mary, and at least one of Henry's children. George Morgan, Stephen's son, and his family are in the next row with Stephen's daughter, Sarah, in the back row. Beside her are her husband, Col. Austin Merrill, and their children. (Photograph taken by the author.)

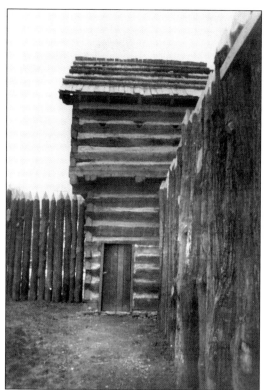

Civilian forts were common along the frontier. They offered sanctuary when hostilities were threatened. In each corner of the fort was a structure like that pictured. This gave the men cover and a vantage point when engaging the enemy. Loopholes were designed into the structure to allow the men to see the enemy and use their muskets without exposing themselves to the danger of being wounded or killed. Several such forts existed around the area now known as Fairmont. Prickett's Fort was garrisoned by American troops during the Revolution. (Photograph courtesy of Prickett's Fort.)

Located adjacent to Prickett's Fort State Park, this cemetery holds the remains of some of the early settlers of Marion County. Prickett, Morgan, Hartley, and Merrill are some of the names found here. The fieldstones in the foreground mark the graves of unknown people who probably died in the late 18th and early 19th centuries. (Photograph taken by the author.)

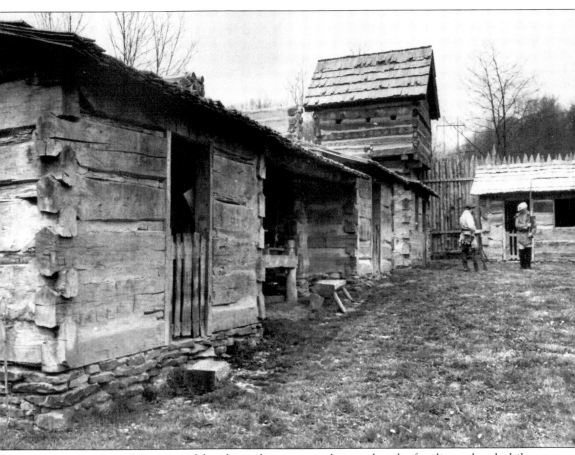

An interior shot of the restored fort shows the accommodations that the families endured while waiting out the threat. In 1777, when the families were "forted up" at Prickett's Fort, two of David Morgan's children were sent to fetch the family cow. Their father, being ill, was lying in bed at the fort. Suddenly he leapt out of bed, grabbed his rifle, and ran from the fort. He didn't go far until he encountered his children. He urged Stephen to go back to the fort to spread the alarm and sent his daughter a short time later. Morgan kept on guard for hostiles and soon engaged two Native Americans. During the fight David, lost two fingers—thus he earned his nickname, "Indian Fighter." (Courtesy of Prickett's Fort.)

The Nathan Fleming Cemetery stands near the intersection of Locust Avenue and Goose Run Road and stands in sharp contrast to the modern scene behind it. These stones from the late 18th and early 19th centuries mark the final resting places of Nathan Fleming, his descendants, and their slaves. Nathan was one of three Fleming brothers who moved westward from Delaware in 1788. (Photograph taken by the author.)

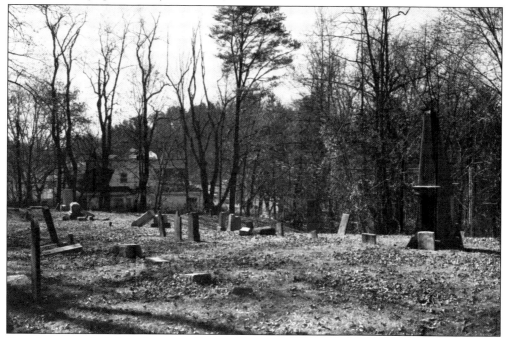

Near the street which bears his name, Benoni Fleming rests with his wife among their descendants and extended family members. (Photograph taken by the author.)

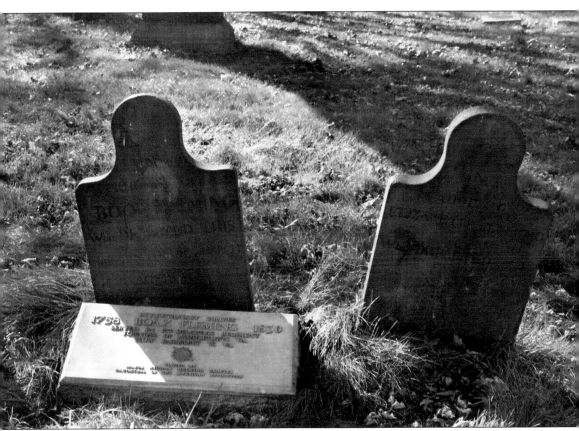

Boaz Fleming and his wife, Elizabeth, were moved from the site of the First Presbyterian Church graveyard to Woodlawn Cemetery early in the 20th century. Boaz had given the original site to the Presbyterian Society for a church when he laid out the town in 1819. Continued growth and financial success lead to the congregation moving and building a new structure a block away and the construction of the Watson Building on that site. Today the Watson Building is home to WesBanco. (Photograph taken by the author.)

Abandoned for close to 75 years, the Fairmont City Cemetery is undergoing a restoration effort. Begun by Robert Allen, a former city council member and a neighborhood resident, the City Cemetery Restoration Project is in its sixth year. The end goal is a heritage tourism site that will draw visitors from around the world. It has already been visited by folks from Pennsylvania, Virginia, New Jersey, Kentucky, Iowa, Wisconsin, and California. (Photograph taken by the author.)

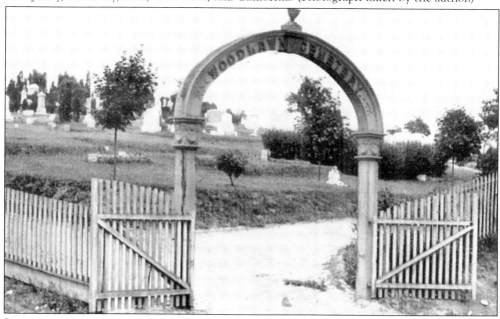

Begun in 1875 with the death and burial of Joseph Richey Hamilton, Woodlawn Cemetery was incorporated in 1885. The fence and gate are no longer there. The entrance has changed dramatically over the last 126 years. Today Woodlawn covers 42 acres and holds over 15,000 graves, including that of Francis Harrison Pierpont, the Father of West Virginia, two governors, numerous national and state legislators, and veterans of all of America's wars. (Courtesy of Diane Hutchinson Parker.)

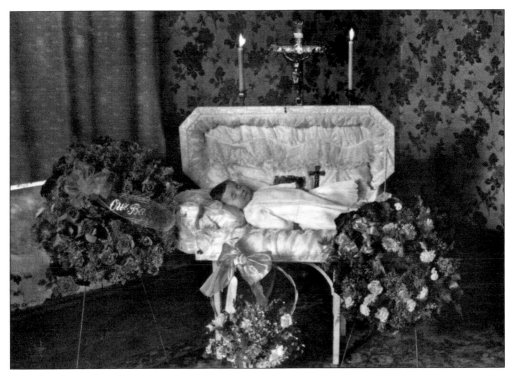

This child's viewing and funeral were most likely held in the house rather than a funeral home, as is common today. The crucifix on the wall above his coffin may also be a clue to the family's religious practices. (Courtesy of West Virginia and Regional History Collection, WVU.)

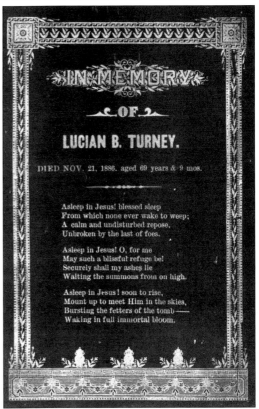

IN MEMORY

OF

LUCIAN B. TURNEY.

DIED NOV. 21, 1886, aged 69 years & 9 mos.

Asleep in Jesus! blessed sleep
From which none ever wake to weep;
A calm and undisturbed repose,
Unbroken by the last of foes.

Asleep in Jesus! O, for me
May such a blissful refuge be!
Securely shall my ashes lie
Waiting the summons from on high.

Asleep in Jesus! soon to rise,
Mount up to meet Him in the skies,
Bursting the fetters of the tomb——
Waking in full immortal bloom.

The memorial card recorded the death date and age of the decedent. The trimmings and iconography of the card could be chosen to best display the family's loss, communicate that loss to the public, and perhaps celebrate the life so recently lost. This particular form was often incorporated into a larger gathering of memorabilia connected to the deceased, thus keeping the connection both symbolically and emotionally. Today funeral homes provide a small remembrance card to the family and friends that may contain a picture of the deceased. (Courtesy of Marion County Historical Society.)

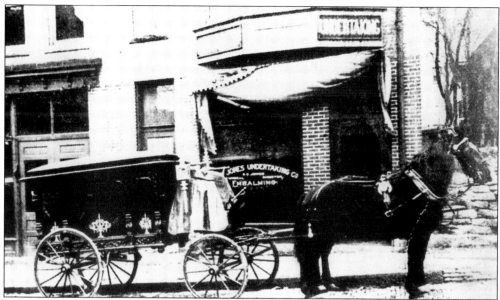

Funerals were held in homes and churches and the bodies conveyed afterward to the place of interment. This hearse and carriage is that of R. C. Jones, a funeral concern begun at the turn of the last century and still in business today. While this team of horses is dark, a team of white horses would have pulled the hearse bearing the coffin of a young child. Other practitioners in business at the time included Eli Musgrave and Sons. The 1860s daybook of Zebulon Musgrave, Eli's father, details what was needed to prepare the decedent for burial. (Courtesy of Marion County Historical Society.)

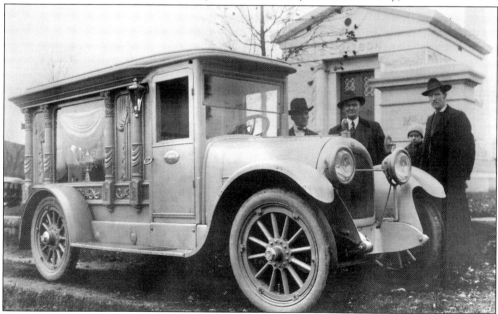

Carpenter and Ford is another funeral home from this period still in business. Oliver Carpenter poses with a new hearse, probably in the 1920s. Oliver's granddaughter and great-grandson carry on the family business. The hearse continued to evolve, as this one has from the horse-drawn carriage to an automobile. Despite that change, the hearse of today has retained many of the characteristics that make it instantly recognizable. (Courtesy of Karen Carpenter Gribben.)

Two

OH, DANNY BOY

Child graves are common in earlier cemeteries, for if they were not killed by disease, children also faced the dangers of life on the frontier. They fell prey to the rigors of daily life, hostile acts, and newfangled contraptions such as trains and automobiles. Over the course of the 20th century, great strides have been made in medical science. We now have vaccines for common childhood illnesses such as the measles, the mumps, and the chicken pox. We also have antibiotics for more serious conditions such as pneumonia and influenza. Diseases such as whooping cough, small pox, and cholera have pretty much been eradicated. Tuberculosis, poliomyelitis, and similar conditions are not as common as they were during the 19th century. As a result, we don't experience near the infant and child mortality rate that was present in the 19th century.

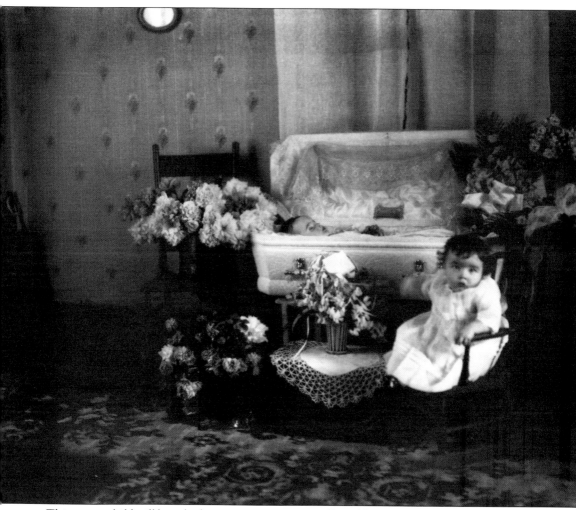

This young child will have had no conscious memory of her older sibling. The image was probably taken to give her a memento mori, a memento of death. Joining the new medium of photography with the Victorian fascination with death, taking pictures of the deceased is still practiced. (West Virginia and Regional History Collection.)

Joseph Hamilton was 14 when, while climbing a fence between his father's farm and that of his neighbor, his gun accidentally discharged. Joseph was buried where he was found. (Photograph taken by the author.)

Little Claude Dunnington was only 10 or 11 months old when he died in 1878. His headstone is carved to depict Christ's cross. The twining ivy is a symbol of eternal life. In the background is his footstone. It is a replica of the base of his headstone and has a small shield carved into it with his initials, C. C. D. (Photograph taken by the author.)

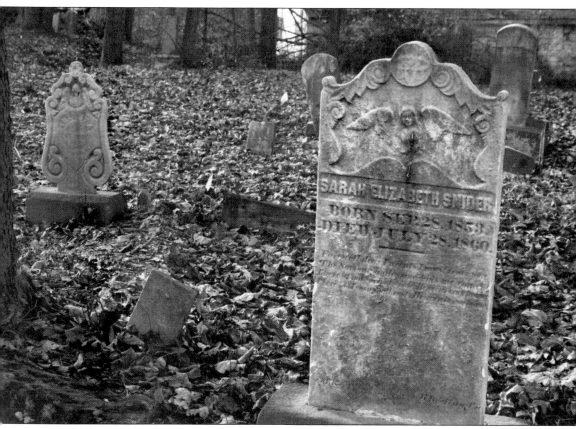

Sarah Elizabeth Snider was only seven years old when she passed. The carver's depiction of an angel is still identifiable after 146 years. Her and her sister Annalisa's stone (to her left in the background) were recovered from the ground. Their brothers, Charles Alfred and John William, are also buried here. The Sniders, Abner and Elizabeth, lost four children in their lifetimes. Few families today have experienced such loss. (Photograph taken by the author.)

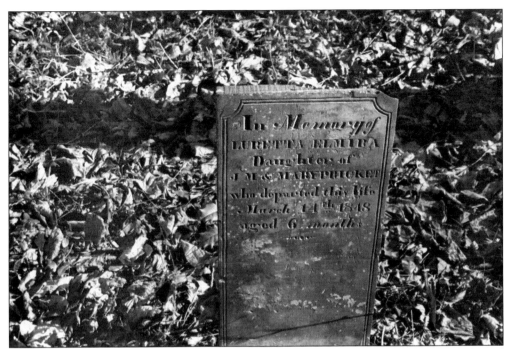

Luretta Prickett was just six months old. Her marker is made of sandstone. The stone is formed in layers naturally. As the stone weathers, the layers crack off one after the other. Eventually, this stone will loose its information. (Photograph taken by the author.)

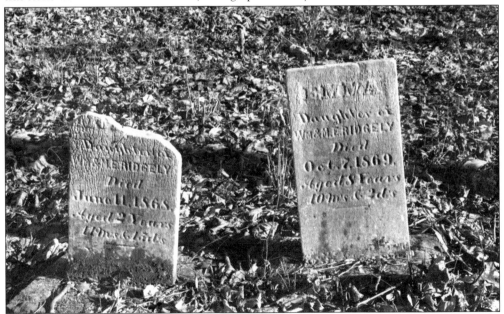

Compare the condition of these stones for the Ridgeley girls, Emma and Molly, ages six and eight. Their markers were made out of a stone that did not weather well. While they were buried at a later date and have therefore not been in the weather for quite as long, parts of their stones are missing or are so badly weathered that their inscriptions are barely legible. (Photograph taken by the author.)

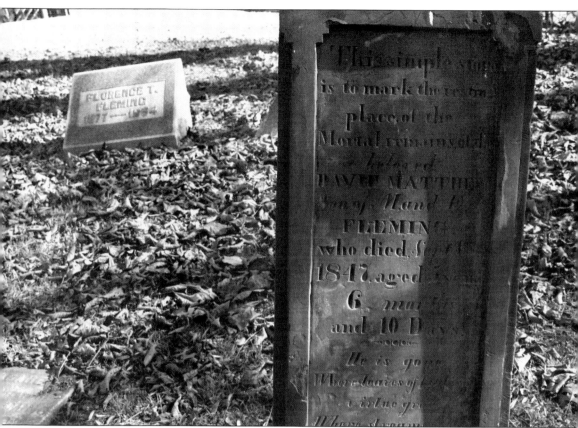

This marker is also of sandstone. The epitaph was carved almost 160 years ago. The grief of his parents is almost palpable. Today the death of a child as young as five would be as devastating but not nearly as common. (Photograph taken by the author.)

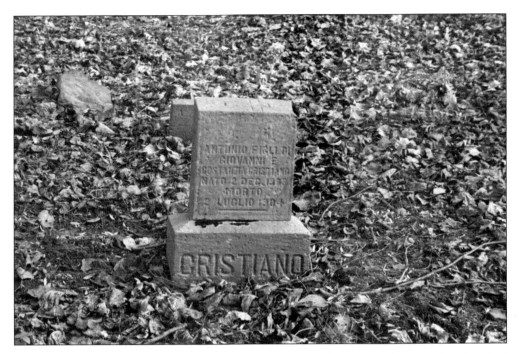

These twins, Antonio and Raffaele Christiano, were not only born on the same day, they died on the same day. The stone is written in Italian and translates: "Antonio, son of Giovanni and Constanza Christiano, born December 2, 1902, died July 12, 1904." This is a double-sided stone. Each twin has one face, and the cross at the top serves both. The stone was discovered lying on its back. Raffaele wasn't found until the stone was set upright. (Photograph taken by the author.)

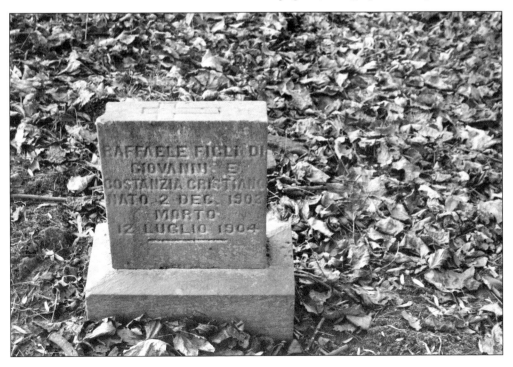

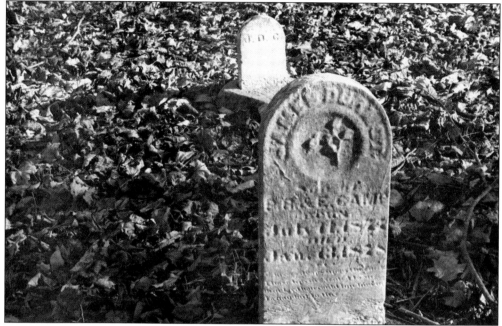

James Dermot Camp was four years old. While last names usually give clues about a person's ethnicity, in this case it is the middle name. Dermot (or Diarmaid in Gaelic) was the name of several ancient Irish kings. James and his family are, therefore, most likely Irish. (Photograph taken by the author.)

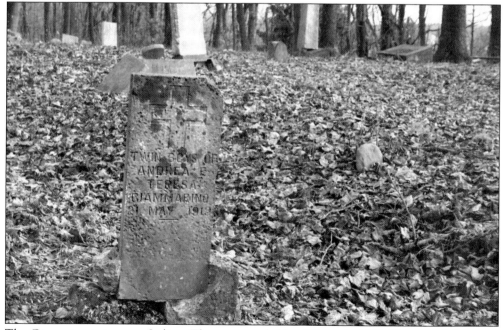

The Giamarino twins were Italian. They were probably stillborn in 1913. This stone's base was brick. Over time, the mortar between the bricks failed, and the stone fell over. This was a surprise discovery once the leaf litter and other debris were removed from the grave site. (Photograph taken by the author.)

Three

The Pipes, the Pipes Are Calling

As with any venture, there will be those who oppose it. At different times throughout our nation's history, we have had to go to war to defend ourselves against another's aggression. Our first adversary was the indigenous peoples who held the land before us. Next, we chose to oppose England in a fight for an independent nation in 1776 and again in 1812. In 1846, it was Mexico and in 1898, the Spanish-American war. However, the most formative war for West Virginia, literally, was the Civil War.

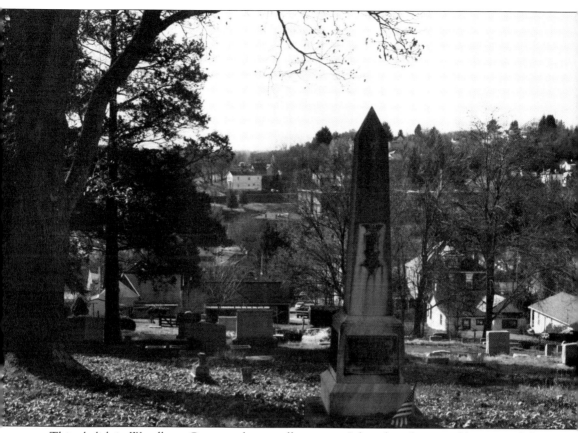

This obelisk in Woodlawn Cemetery honors all veterans. It has three bronze tablets around the lower portion of the stone. The Marion County Veterans Council recently replaced the flagpole and has pledged to have another tablet made to honor veterans from our most recent wars. (Photograph taken by the author.)

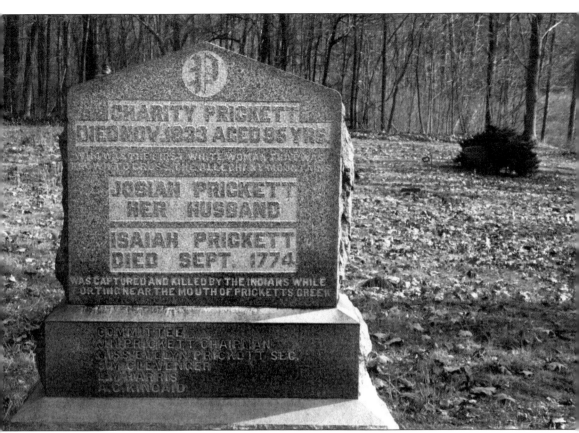

Isaiah Prickett was 14 when he was attacked and scalped by Shawnees just outside of Prickett's Fort. He was not the first to fall to hostiles, nor would he be the last. It is said that Isaiah was handsome, charming, and popular with the ladies. His death is thought to have been a revenge killing for the murder of Mingo chief Logan's family by David Greathouse. (Photograph taken by the author.)

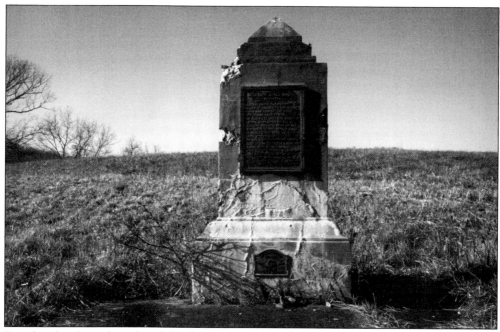

Standing lonely vigil in a hay field, this monument marks the grave of Capt. James Booth. Near this spot in 1778, a simple lapse in vigilance proved fatal. This monument was set in the early 1930s by the Maj. William L. Haymond Chapter of the Daughters of the American Revolution. In addition to his other accomplishments, Booth was a captain of the militia and served during the Revolutionary War. This monument is showing its age. The Marion County Historical Society is seeking funds to restore it. (Photograph taken by the author.)

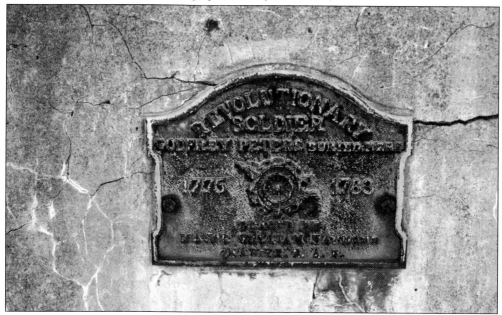

This bronze plaque commemorates Booth's participation in the Revolutionary War. On the back of the monument, another plaque commemorates Godfrey Peters, also a veteran of the Revolutionary War. (Photograph taken by the author.)

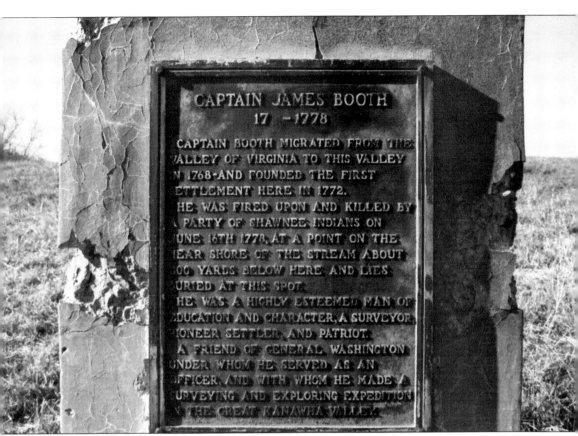

The plaque reads, "Captain James Booth (17[09] – 1778). Captain Booth migrated from the Valley of Virginia to this valley in 1768 and founded the first settlement here in 1772 [Boothsville]. He was fired upon and killed by a party of Shawnee Indians on June 16th, 1778 at a point on the near shore of the stream about 200 yards from here and lies buried at this spot. He was a highly esteemed man of education and character, a surveyor, pioneer, settler and patriot, a friend of General [George] Washington under whom he served as an officer and with whom he made a surveying and exploring expedition in the Great Kanawha Valley." (Photograph taken by the author.)

This monument commemorates Nathanial Cochran. He was with Booth when he was killed. Cochran was taken captive and sold to the British. After spending five years in prison, Cochran was released and went to Hagerstown, Maryland. Nathaniel and Elizabeth (Ford) Cochran then walked to western Virginia from Hagerstown, a distance of 156 miles. They settled at Thoburn. Cochran built a one-room house without a chimney or window and with one stout door. The Cochrans planted apple, peach, and pear seeds they had brought with them, and the trees were bearing fruit in three to five years. Nathaniel Cochran was appointed a captain and led the 1st Battalion of the 11th Regiment of the Virginia Militia in 1802. He died in 1808. (West Virginia and Regional History Collection.)

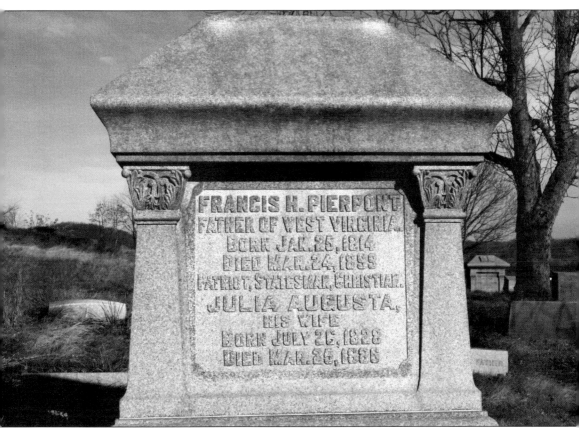

The Pierpont monument further details the life and work of Francis H. Pierpont, the father of West Virginia. Pierpont returned from Virginia after being replaced as governor and took up his law practice. He served one term in the West Virginia House of Delegates. Pierpont later served as president of the General Conference of the Methodist Protestant Church. He died in 1899. Three of Pierpont's four children are buried here as well. (Photograph taken by the author.)

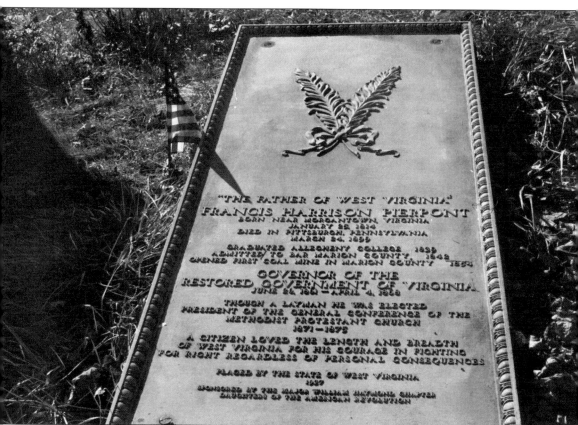

Francis Harrison Pierpont took part in the Wheeling Convention in 1861, in which it was decided that since Virginia had seceded from the Union, those holding office in that state no longer constituted a government. It was decided to form a new government. Pierpont was appointed governor of the Restored State of Virginia and held office from 1861 to 1868. The Wheeling Convention not only restored the government of Virginia, it petitioned Congress to create a new state from that Virginia's northwestern counties. Lincoln signed the declaration in April 1863, and West Virginia became a state on June 20, 1863. The bronze tablet on the graves of Pierpont and his wife were placed by the Maj. William L. Haymond Chapter of the Daughters of the American Revolution. (Photograph taken by the author.)

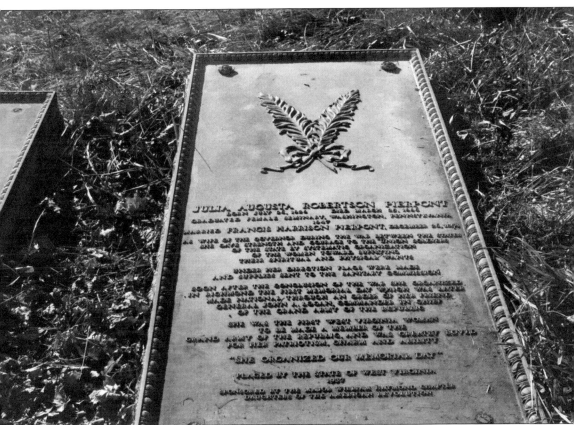

Julia Augusta Robertson Pierpont became concerned with the condition of the graves of soldiers in the Hollywood Cemetery in Richmond, Virginia. She and a group of her friends and children from the colored school chose to clean up and decorate these graves. Thus, she is credited by some historians with the creation of Decoration Day, later to be known as Memorial Day. On this day, the graves of veterans of all wars are decorated with a small American flag to show honor and acknowledge their sacrifice. (Photograph taken by the author.)

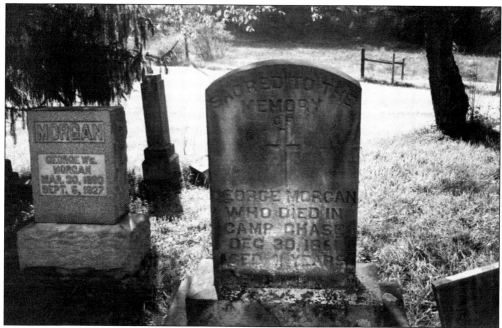

The formation of the new state was by no means the desire of all the citizens. There were those who chose to fight with the Confederacy. Very early in the war, George Pinckney Morgan, great-grandson of David Morgan, was captured on Cheat Mountain and was sent to Camp Chase, a prison for Confederate soldiers near Cincinnati, Ohio, where he died on December 30, 1861. (Photograph taken by the author.)

The most famous battle of the war for folks in Fairmont was not Antietam or Gettysburg but Jones's Raid, locally known as the Battle of Fairmont, fought on April 21, 1863. Confederate general William "Grumble" Jones undertook a series of raids into western Virginia with the objective of capturing Francis Pierpont and destroying railroad bridges. While he managed the latter, he had to content himself with burning the library of the former. (Courtesy of West Virginia and Regional History Collection, WVU.)

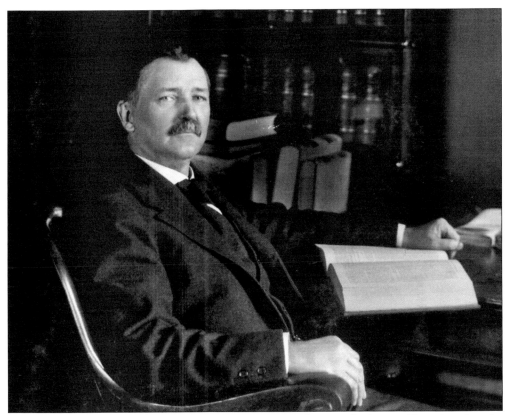

Judge William Stanley Haymond, born in 1852, was 10 when war broke out. He enlisted in the Confederate army as a courier. He was assigned to the command of Gen. John D. Imboden and was at one time a courier for Robert E. Lee. The William Stanley Haymond Chapter No. 1824 of the United Daughters of the Confederacy was formed in October 1925. (Courtesy of the Marion County Historical Society.)

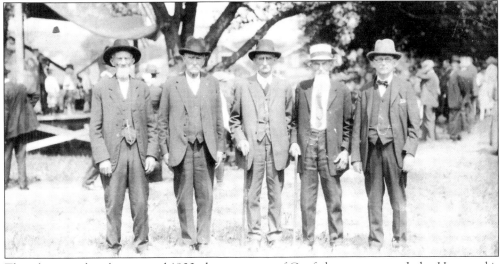

This photograph, taken around 1900, shows a group of Confederate veterans. Judge Haymond is on the far right. (Courtesy of Jonathan Watson.)

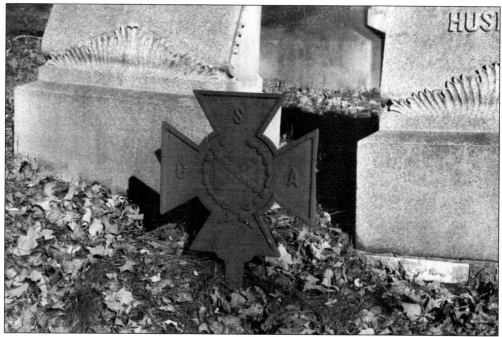

This marker indicates that this is the grave of a Confederate veteran. These iron crosses were placed between 1890 and 1920 to mark the reality of the Confederate States of America. Three blades of the cross are marked C, S, and A. On the reverse is the motto *Dio Vindici*—God will vindicate. (Photograph taken by the author.)

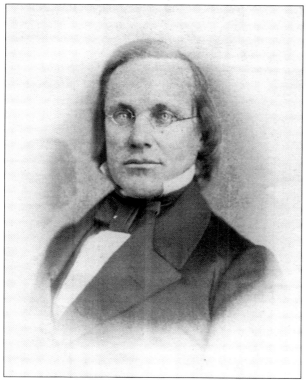

Zedikiah Kidwell (1814–1872) was a two-term congressman for the state of Virginia, a member of the Virginia House of Delegates, one of the men who worked to create Marion County in 1842, a doctor, a lawyer, a schoolteacher, and he had worked in a dry goods store. However, he also stood for election to the Congress of the Confederate States of America. After the war, he was prohibited from holding public office, as were all Confederates. The ban was lifted in 1872. (Courtesy of West Virginia and Regional History Collection, WVU.)

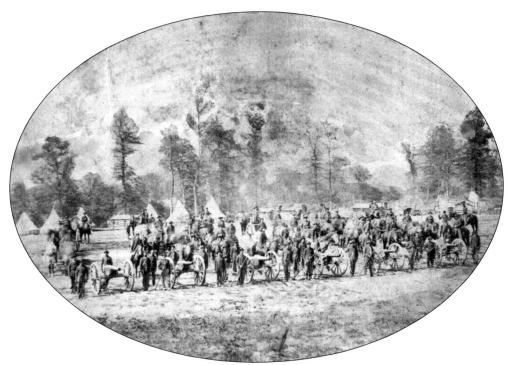

Veterans of Battery F are buried at Maple Grove Cemetery in Fairmont. (Courtesy of West Virginia and Regional History Collection, WVU.)

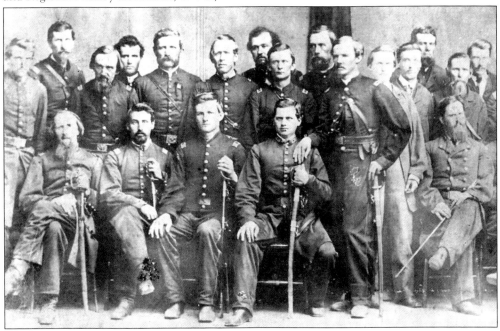

Although there were men who fought for the South, the area was strongly for the Union. The number of men who fought in blue far exceeded those who wore grey. West Virginia fielded several regiments of infantry, seven of cavalry, and eight batteries of artillery. This group photograph of Union veterans was taken about 1880. (Courtesy of Jonathan Watson.)

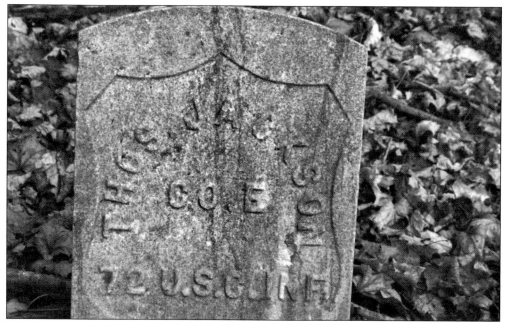

Thomas Jackson, Company E, 72nd Infantry, United States Colored Troops (U.S.C.), was one of about 80,000 troops of African Americans who fought with the Union. This regiment was organized at Covington, Kentucky, on April 18, 1865, and was discontinued on May 3, 1865. Both he and Jenkins are buried in the black section of Woodlawn Cemetery. (Photograph taken by the author.)

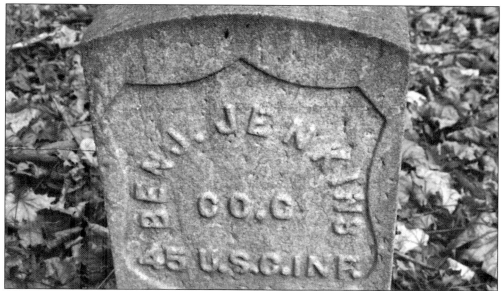

Benjamin Jenkins, Company C, 45th Infantry, U.S.C., enlisted in the summer of 1864 and saw action over the last year of the war. He was probably from Philadelphia, as this regiment was deployed from Camp William Penn. The regiment was mustered out at Brownsville, Texas, on November 4, 1865, where they had been serving as prison guards. Some 40 years later, Jenkins would stand on the courthouse steps with other Union veterans and be photographed. (Photograph taken by the author.)

Four

'TIS YOU MUST GO

Immigration has been an issue in America since the first European adventurers made landfall. The ripples of world history have carried people to these shores for a variety of reasons over the centuries. Religious and political persecution, famine, economic instability, and opportunity have all been motivating forces.

There have been people in the Fairmont area since the Adena mound builders of roughly 1000 BC. Tribes of Eastern Woodland Indians such as the Seneca, Mingo, and Delaware had built semi-permanent hunting and fishing camps throughout West Virginia. The first European settlers came during the early 18th century but didn't meet with great success until about mid-century.

The Fleming brothers—Nathan, Benoni, and Boaz—were the sons of William Fleming. He had emigrated from Northern Ireland in 1714. After two centuries of religious and political upheaval, the Church of England had gained the upper hand. English Parliament began passing laws that were unfavorable to both the Irish Catholic and the Scots Presbyterian. Faced with the loss of land, position, and wealth, many chose to leave. The family's second immigration, into western Virginia, began in 1788. Other names in their party were Hutchinson, Hamilton, Hudson, Frame, Wolcot, Pence, Brummage, and Krotzer.

The daughter of Boaz Fleming, Clarissa (1786–1863) was two years old when the family migrated from Delaware to Virginia in 1788. Her father laid out the town of Middletown in 1819. He named the town for his wife's hometown of Middletown, Delaware. Clarissa married James Hamilton and shares a stone with him in Woodlawn Cemetery not far from her parents. Her son, Elmus Hamilton, would start a family graveyard here with the death of his son Joseph Richey, joining a small part of his sheep yard with a small piece of land on the Barns farm. The two families used the area as a burying ground before incorporating a cemetery company in 1885. (Courtesy of the Marion County Historical Society.)

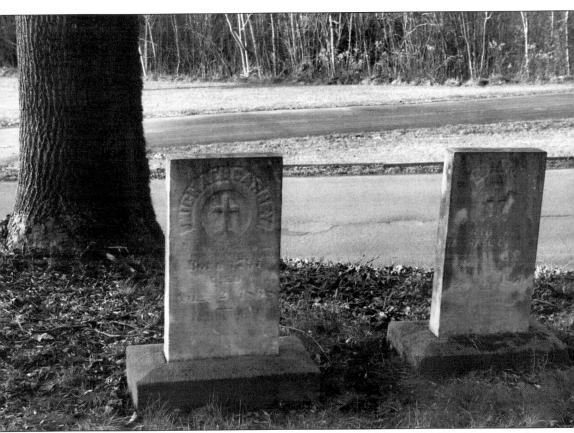

Michael Carney and his wife, Mary, emigrated from County Donegal about 1814. The family moved to Middletown, Virginia, about 1828. He and Mary had six children: Bridget, John, Cornelius, Hester, Ellen, and Frank. (Photograph taken by the author.)

By mid-century, the Irish immigrants had increased in number largely due to the man-made potato famine. Forced to leave home or starve, Bridget Quinn is believed to have immigrated in 1846. She would have been 16. She most likely served a seven-year term of indenture, after which she would have been free to marry. She and Patrick Monaghan were married on October 10, 1854. Their oldest son, Patrick, was born two years later. Bridget and Patrick died within a month of each other in 1871, leaving behind five children, Patrick, Sarah, John, Catherine, and Margaret Marion, ranging in age from 15 to 3. Another daughter, Mary, was born after Patrick but died shortly before her first birthday. She is recorded as being buried here, although no stone has been found for her yet. (Photographs taken by the author.)

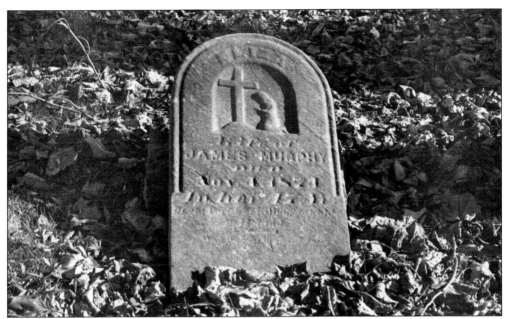

There were three Murphy families in Fairmont in the 1850s. All three men worked as watchmen on the Baltimore and Ohio Railroad. They, their spouses, and their children are all buried in the City Cemetery. James Murphy was born in County Wicklow in 1814. He shares a stone with three of his children, James W., Thomas, and Ann. Eliza, James's wife, is buried across from her husband and children. (Photograph taken by the author.)

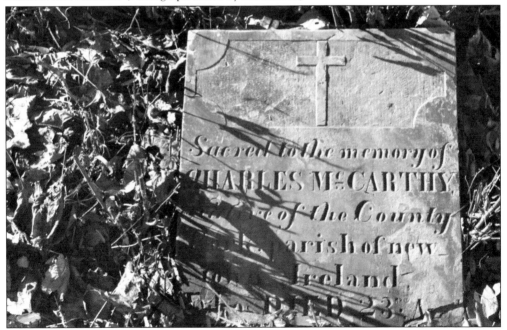

Charles McCarthy was probably killed working on the railroad, bringing it through Fairmont from Baltimore by June 1852. His stone attests to the merits of his character and is a fitting tribute to a man admired by his coworkers. Charles was from New Town Parish, County Cork. (Photograph taken by the author.)

Ignatius Ghering was a native of Württemberg, Germany. He had been living in Kingwood in Preston County. Because there were not enough Catholics in the area to support a permanent parish, an itinerant priest would come periodically to hold mass. While he was in the area, he stayed with Ignatius. Once a "critical mass" of Catholics had been attained, St. Peter's Parish was established in Fairmont, and the same itinerant priest was assigned to it. Ignatius moved his family from Kingwood to Fairmont to be a part of that parish. (Photograph taken by the author.)

Around the beginning of the 20th century, Italians began to settle in Fairmont. They came to work the coal mines in the area. There were now enough Catholics to support two parishes. St. Peter's was the Irish church, and St. Joseph's was the Italian church. There are at least six stones written in Italian in the Fairmont City Cemetery. Brune Greco's stone had at some point fallen over and rolled down the hillside. The stone has been excavated and moved back to its proper location. (Photograph taken by the author.)

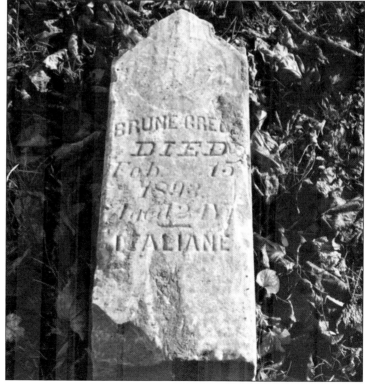

Five

ALL MY DREAMS WILL WARM AND SWEETER BE

With the completion of the railroad, the coal seams in the area became a highly valuable commodity. For the first time, coal could be shipped by rail to the Eastern Seaboard. The men in the area were quick to see this, and commercially viable coal mines fueled Fairmont's economy throughout the latter half of the 19th century into the 20th century. Many of these mines are still producing coal. With their newfound wealth, the citizens of Fairmont built grand homes and impressive business buildings. James Otis Watson is usually the first to be pointed out as one of Fairmont's coal barons. He opened a coal mine in 1852 that gave rise to today's Consolidation Coal. Clyde Effington Hutchinson, however, built perhaps one of the grandest homes, Sonnencroft.

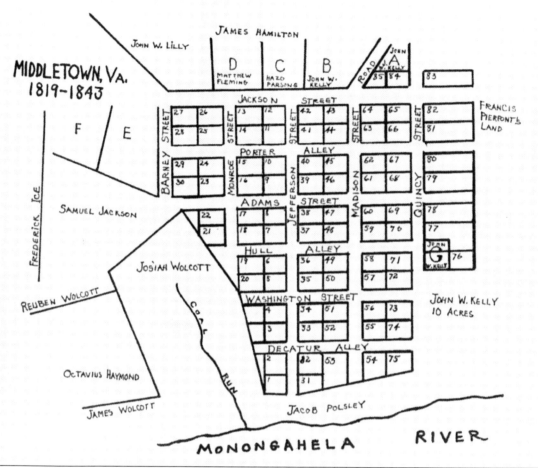

This is the first known map of Middletown (Fairmont), showing the lots and surrounding landowners, (notably Francis Pierpont on the right and Jacob Polsley at the bottom of the image). Lot 40 was given to the Presbyterian Society for a church that was built in 1823. The Middletown Academy was built on Lot 21 in 1828. Leonard Nuzum bought Lot 43 for $41, sold it to Michael Carney in 1828 for $10, and Carney sold it in 1839 for $350. Boaz's town was prospering. However, owning land in two counties (Harrison and Monongalia), Boaz had to travel to two county seats (Clarksburg and Morgantown) to pay taxes. He proposed a new county but was unsuccessful. Marion County would not come into being until 1842. (*Now and Long Ago*, page 426.)

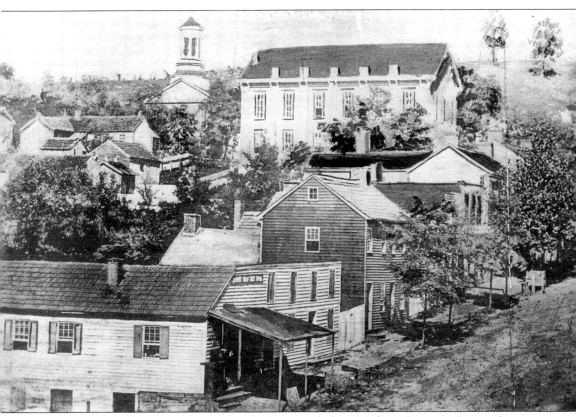

This photograph shows Fairmont *c.* 1870 looking south from Madison Street to Quincy Street. Just 50 years old, Fairmont was thriving. Its business district was varied and diverse and met the needs of the town residents as well as those of the outlying area. Farming was still the occupation of the majority of the residents, with Elmus Hamilton and Thomas Barnes owning large acreage just up the hill to the right. The Methodist Protestant church is pictured just left of center in the background. The two-story building to its right was a public school. Only the gable of the Burns home can be seen to the right. In front of the Burns home is the Chisler Store; in front of that, the Eyesler Home, and then the Edd McCray Store and home. The Larney Carr home is on the left, just below the church. (Courtesy of the Marion County Historical Society.)

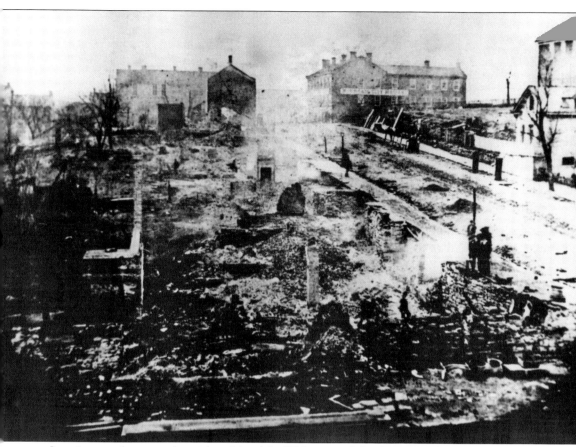

Just six years later, on the night of April 1, 1876, most of the downtown business district was reduced to smoldering ash. Desperately buckets were passed along a line of men stretching from the river to Adams Street, as they tried to battle the flames. Although the loss was devastating to some residents and business owners, the buildings that replaced those destroyed in the fire were made of brick and stone. Cornelius Carney, Michael's son, was insured and able to recoup his losses. He would go on to build the Carney Block of businesses on the west side of Jefferson Street from Adams Street to Madison Street. (Courtesy of West Virginia and Regional History Collection, WVU.)

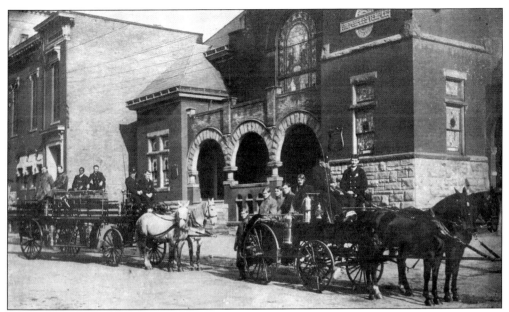

Around 1903, the city's fire department was housed first on Cleveland Avenue and then in the City Building on Monroe Street. These horse-drawn carriages were better than what the city had in 1876, but they still weren't adequate for the growing city's needs. A more recent fire scare in the Cunningham Building prompted the populace to ask for a new hook and ladder. The men and their equipment are posed in front of the People's Temple, a Methodist church opposite the City Building. (Courtesy of the Marion County Historical Society.)

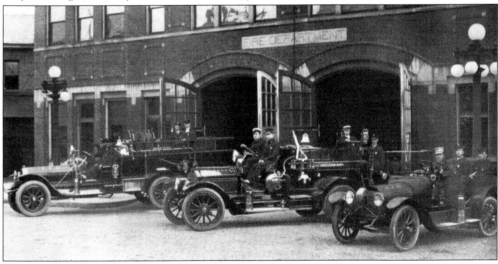

Purchased in 1916, these vehicles upgraded the fire department and led to more efficient firefighting and fiscal responsibility. Previously the company had maintained seven horses. In the four and one half years the equipment had been in use, the department saved enough on grain, shoeing, care, harness, and assorted expenses incurred with the care of horses to pay for all three vehicles plus all the gasoline and maintenance required to keep them running. Unfortunately, Old Storm, the chief's horse, and his six stable mates were put out to pasture. (Photograph courtesy of the *Report of the Several Departments under Commission form of Government, Fairmont, WV: from January 1st, 1914 to July 1st, 1919.*)

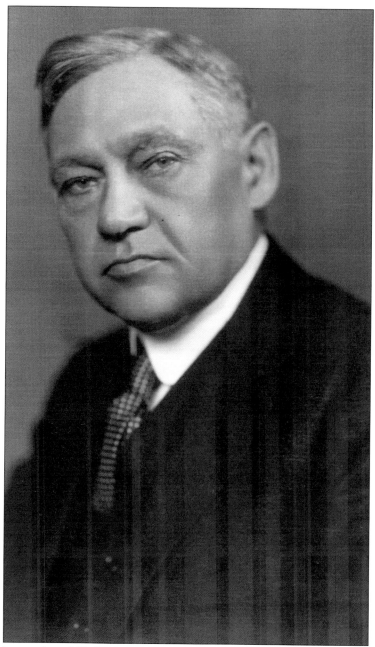

The son of Jeremiah and Katherine Hutchinson, Clyde Effington Hutchinson was born in Smithtown on July 16, 1859. He ran several stores in his early manhood and married in 1886. He entered the coal business shortly after coming to Fairmont and met with great success. He and James Otis Watson are considered pioneers in the northern coalfields, particularly the Fairmont Field. They were successful in opening and running several mines that later formed the basis of Consolidated Coal. He died unexpectedly at the Daniel Boone Hotel while on a business trip to Charleston on September 28, 1926. He was a 32nd-degree Mason, an Elk, he belonged to the Knights Templar, and he was a congregant of the First Baptist Church. (Courtesy of Diane Hutchinson Parker.)

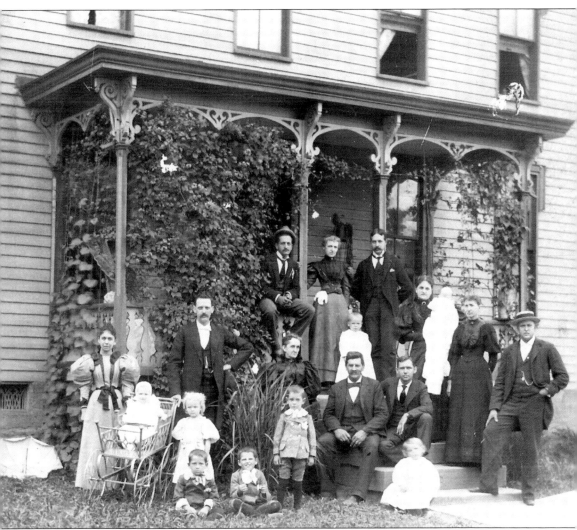

In this 1895 photograph, Mary Lyda Watkins Hutchinson and her husband, Clyde, are posed with Lyda's family, the Watkinses. Five of the couple's sons are pictured. Pictured from left to right are (first row) Edwin and Wilma Watkins; Brooks, Lee, and Claude Hutchinson; Charles Watkins Sr.; Clyde Hutchinson; Mollie and Gus Watkins; and Frank Hutchinson is seated below his father wearing a white dress; (second row) Clara and Charles Watkins, Lyda Pauline Swearingen Watkins, unidentified boy, and Mary Lyda Watkins Hutchinson holding her son Harold; (third row, on the porch) Okey, Emma, and Bruce Watkins. (Courtesy of Diane Hutchinson Parker.)

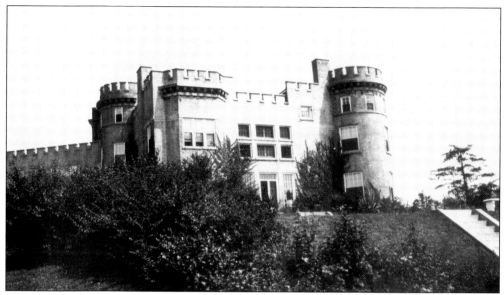

By 1912, the Hutchinson family had prospered so well that C. E. built a replica of the castle at Inverness, Scotland. His wife had been so taken with it on their trip to Europe that Clyde built her this home and called it Sonnencroft. The German *sonnen* means sons, and the word *croft* means house—thus, the House of Sons. (Courtesy of Diane Hutchinson Parker.)

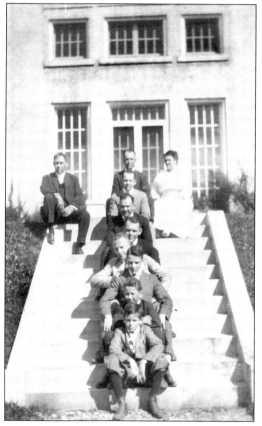

Flanked at the top step by his parents, Clyde Effington Hutchinson (left) and Mary Lyda Watkins Hutchinson, is Claude Ernest, down the steps is then Brooks Swearingen, Bernard Lee, Frank Ehlen, Harold Herbert, Paul Mason, Robert Jay, and James Jeremiah. This photograph was taken *c.* 1914. (Courtesy of Diane Hutchinson Parker.)

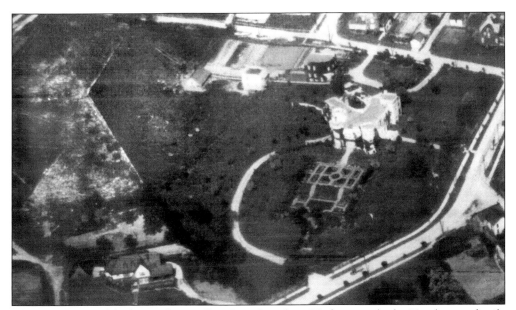

This aerial view of the home shows off its formal gardens. Unfortunately the Hutchinson family suffered, as did many others, in the Great Depression. They were not able to keep it up, and it was sold for taxes. Circuit Court judge Harry Shaw, whose house is in the lower left corner, bought the property. His daughter-in-law tried to convey the property to the board of education following the judge's death. To do so, she had to destroy the residence, which she did in the 1960s. (Courtesy of Diane Hutchinson Parker.)

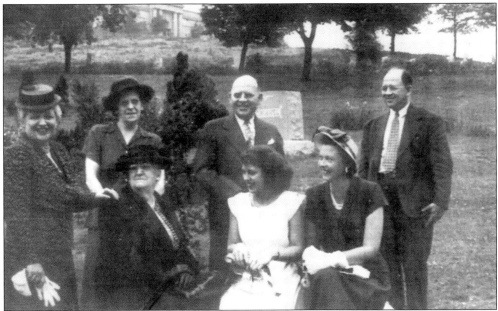

This family outing, c. 1946, includes, from left to right, (seated) Mrs. Owens, Diane Hutchinson, and Pauline Findley (Paul) Hutchinson; (standing) Ray Pefley (Brooks) Hutchinson, Margaret Owens (Harold) Hutchinson, Harold H. Hutchinson, and Brooks Hutchinson. They are visiting those who have gone before them at the place where they themselves will rest. The Hutchinson family has been connected to Woodlawn since its inception. (Courtesy of Diane Hutchinson Parker.)

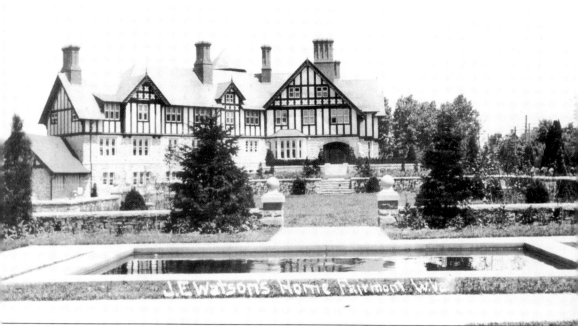

High Gate, this Tudor Revival house, was completed in 1912. It was the home of James Edwin Watson, a son of James Otis. The Watson family's fortunes had expanded from coal mining to include oil and gas, real estate, hotels, and banking. Today the building has been restored and placed on the National Historic Register. The Ross Funeral Home is housed here, and the reflecting pool and stone walls have disappeared. A period reproduction cast iron fence encloses the property, which includes a carriage house in the left rear of the property. The carriage house is used to host historic preservation workshops, receptions, and organization meetings. (Courtesy of the Marion County Historical Society.)

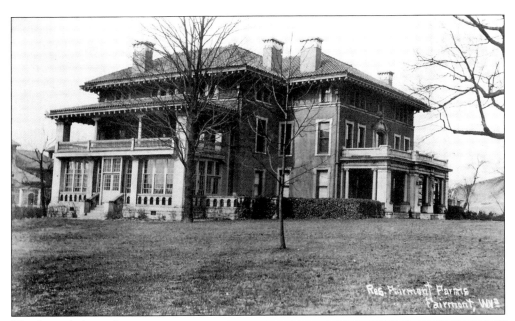

This home belonged first to James Otis Watson and was known as La Grange. It was remodeled by his son, Clarence W. Watson, and became known as Fairmont Farms. C. W. kept a stable of world-famous show horses on his estate. C. W. was also a United States senator and held a high position in the army during World War I. Men of standing came from far and near to visit Fairmont Farms. (Above courtesy Marion County Historical Society; right courtesy of Jonathan Watson.)

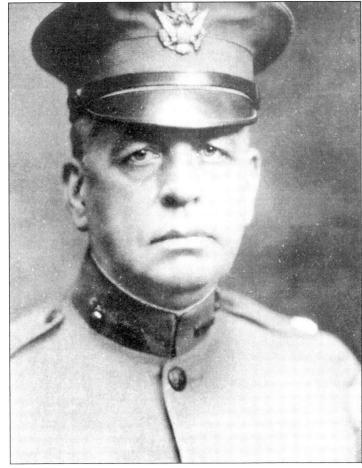

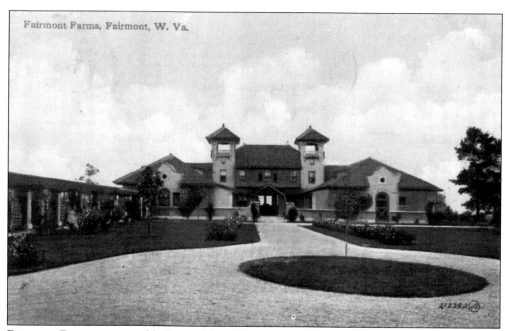

Fairmont Farms, Fairmont, W. Va.

Fairmont Farms was a world-class stable of horses owned by Sen. Clarance W. Watson. This Spanish Mission–style complex housed the horses and their gear as well as housing for their grooms and other household staff. (Courtesy of Blackwood Associates.)

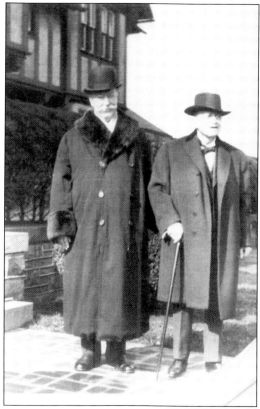

William Howard Taft (left) and A. B. Fleming enjoy a visit to Fairmont Farms, c. 1914. (Courtesy of Marion County Historical Society.)

Six

COAL MINING

When settlers first came to the area, coal was not appreciated as an energy source outside the home. At many points, the coal bed was actually aboveground, and individuals would mine the readily available coal for local use. Commercial sale of coal was not viable until after the Industrial Revolution and its accompanying demand for coal to fuel its machines. Transportation was also an issue. Once the Baltimore and Ohio Railroad came through, coal could be shipped to the eastern or tidewater markets.

Coal mining is a dark, dirty, and dangerous occupation. Generations of men have spent their working lives on their knees shoveling coal to fuel the nation's industries. Early efforts to unionize the miners were unsuccessful in the Fairmont Field. The miners benefited from the strikes of other miners in surrounding states because their coal found a ready market and kept coal production, and therefore work and wages, at a strong pace. Coal mines were opened on Coal Run and along the Monongahela River. Recent emigrants from Italy and Eastern Europe came to the coal fields to find work and raise their families.

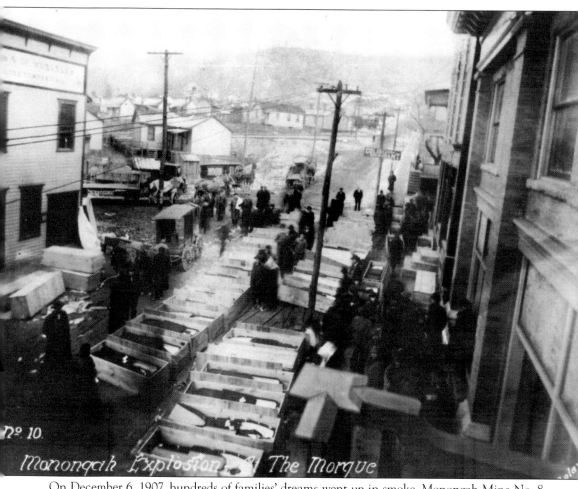

No. 10.

Monongah Explosion. No. 4 The Morgue

On December 6, 1907, hundreds of families' dreams went up in smoke. Monongah Mine No. 8 erupted in an explosion and fire that killed at least the 361 men and boys known to have been working at the time, and they may well have killed another few hundred in the immediate area of the mine's mouth. (Courtesy of West Virginia and Regional History Collection, WVU.)

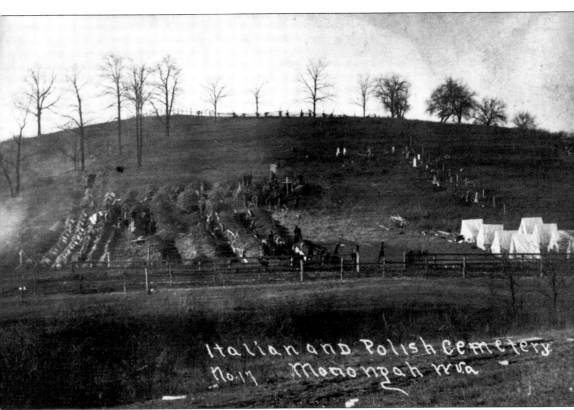

Italian and Polish Cemetery
No. 17 Monongah WVa

Crews of grave diggers were called out to open enough graves to inter the remains of the miners. The tents on the right were pitched to house the crews. This photograph is identified as the Italian and Polish cemetery. As the men had been segregated in life, so were they set apart in death. (Courtesy of West Virginia and Regional History Collection, WVU.)

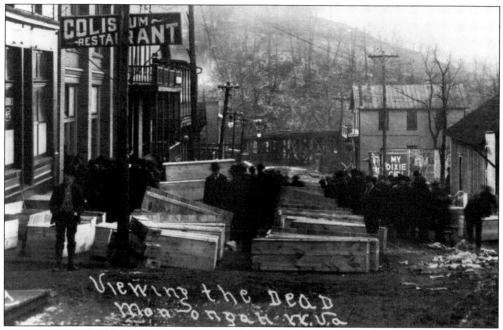

Row upon row of coffins lined the street of Monongah, where the remains could be viewed in an attempt to identify the dead and say a last farewell. Wagons laden with their grisly burden drove between the street morgue and the cemetery to inter the dead in as timely a fashion as possible. (Courtesy of West Virginia and Regional History Collection, WVU.)

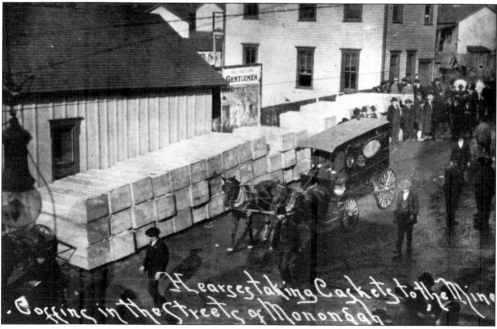

Empty coffins lined the street, waiting to be taken to the mine and filled with the remains of one or more miners. Oliver Carpenter was one of the undertakers who dealt with the large volume of dead who needed to be transported from the mine site to the hastily prepared cemeteries. (Courtesy of West Virginia and Regional History Collection, WVU.)

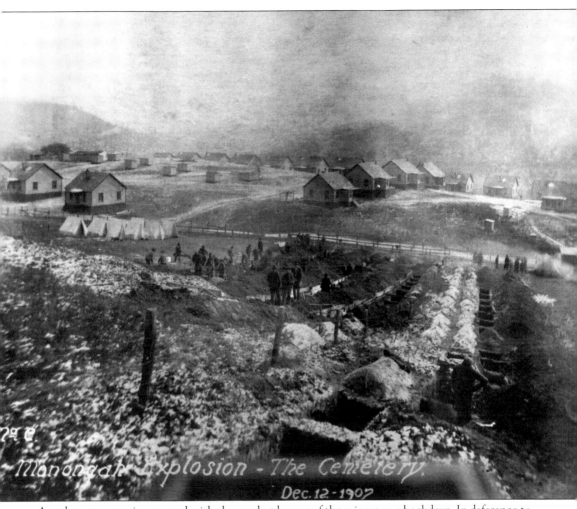

Monongah Explosion – The Cemetery.
Dec. 12 - 1907

Another cemetery is prepared with the modest homes of the miners as a backdrop. In deference to their loss, the families were allowed to remain in the homes for a time without charge. (Courtesy of West Virginia and Regional History Collection, WVU.)

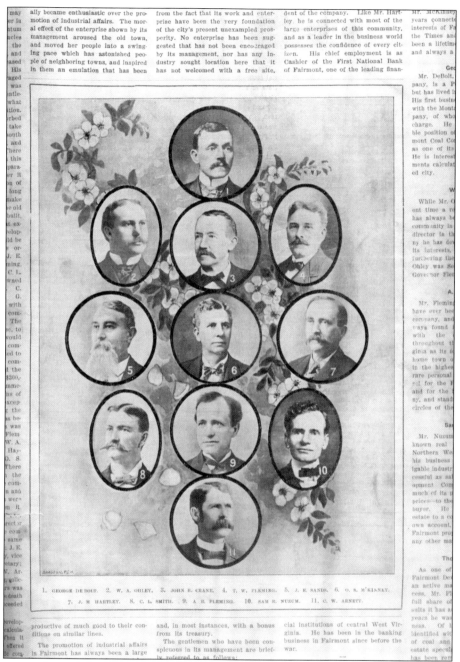

1. GEORGE DE BOLT. 2. W. A. OHLEY. 3. JOHN B. CRANE. 4. T. W. FLEMING. 5. J. E. SANDS. 6. O. S. M'KINNEY. 7. J. M HARTLEY. 8. C. L. SMITH. 9. A B. FLEMING. 10. SAM R. NUZUM. 11. C. W. ARNETT.

These men formed the Fairmont Development Company in 1890 and guided the growth and improvements to create the city of Fairmont, incorporated in 1899. It took in the surrounding areas known as West Fairmont and Palatine in its new configuration. This c. 1908 advertisement is from a newspaper insert touting the accomplishments of the city as it strove to become the best in the state. A. B. Fleming (#9) was governor of West Virginia from 1893 to 1895; J. M. Hartley (#7) owned and operated a major department store; J. E. Sands (#5) was a cashier of a major bank; Sam Nuzum (#10) was a furniture dealer and a major business leader in the Merchant Street area; and C. W. Arnett (#11) was a real estate developer. (Courtesy of Jonathan Watson.)

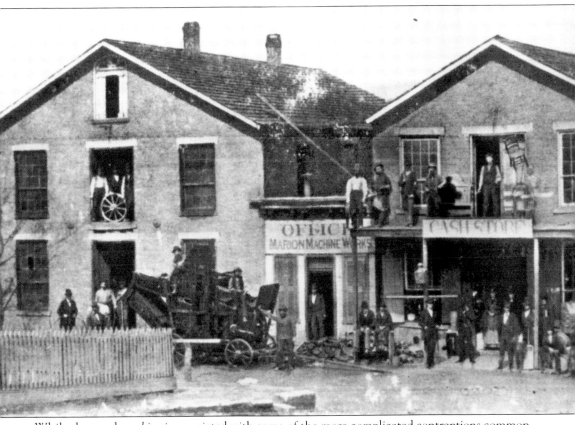

While the word *machine* is associated with some of the more complicated contraptions common to life, the term also connotes the metal parts of other vehicles, such as the metal bands affixed to wooden wagon wheels in the latter part of the 19th century. The track and spikes needed in laying roads for the railroad and the mining industry, as well as the coal cars used in hauling coal from inside the mines, are machined items—that is, they are forged and manufactured in supporting industries that arose from the blacksmith shops of earlier days. This is probably a coach in front of the Marion Machine Works; the wagon wheel is being worked on in the upper story, and the chairs are manufactured and repaired here. (Courtesy of West Virginia and Regional History Collection, WVU.)

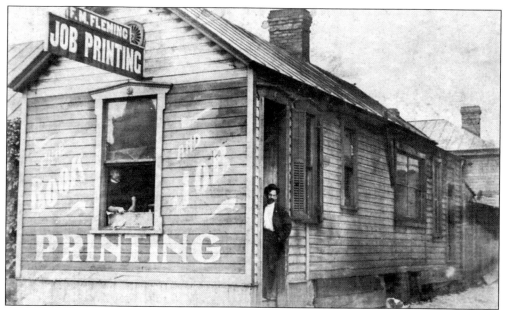

The Flemings soon moved out of farming and into other areas of business. Francis Marion Fleming opened a print shop; Ben Fleming made hats at his store on the corner of Main and Jefferson Streets, was mayor of Fairmont in 1860 and 1861, and served in the state legislature from 1867 to 1868; Benjamin Dolph Fleming was into lumber, fruit, a dairy, and banking; Frank John Fleming was a millwright; and Matthew Fleming, son of Benoni, was a blacksmith. He was also a justice of the peace (1828–1850) and sheriff of Marion County (1850–1851). (Courtesy of the Marion County Historical Society.)

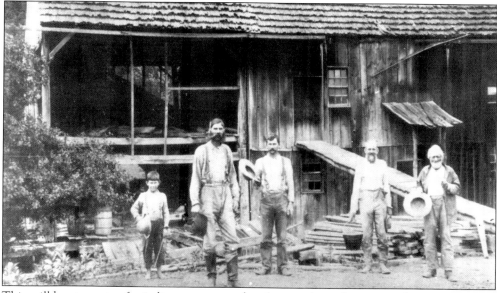

This mill has two sets of grinding stones, one for wheat and one for corn, and a water-powered sawmill was attached to the building complex. The mill was owned by McKinney and McElfresh. The men pictured are, from left to right, Edward A. Morgan, G. W. Hawkins, J. Hayes Morgan, G. W. McElfresh, and Harvey Reeves. The photograph was taken in 1892. (Courtesy of the Marion County Historical Society.)

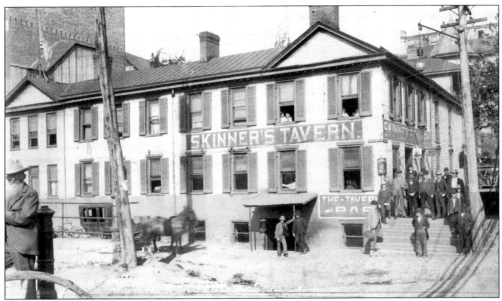

Skinner's Tavern stood on the corner of Cleveland Avenue and Madison Street. Its close proximity to the railroad passenger station lent it easy access for those headed to and from Washington, D.C., and points west. Probably built in 1847, the establishment enjoyed a reputation for good if unusual food (its menu sometimes included venison and other wild game) and as one of the best hotels in Fairmont. The business changed hands a number of times but was always a hotel and restaurant. Additions were made in 1903 and 1904, and these remain, while the wooden central section of the hotel has been destroyed. (Courtesy of the Marion County Historical Society.)

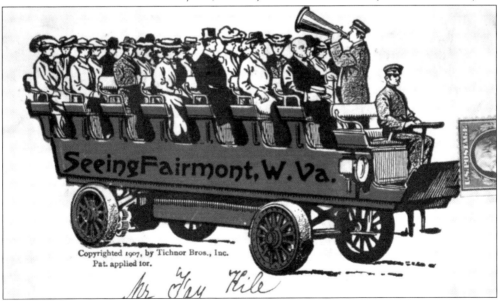

While it is not likely that these folks would have actually had a touring car such as this, this invitation to the public to see Fairmont met with a good deal of success. Fairmont became a popular place to visit, prompting the construction of a large hotel in such a way as to allow for expansion of the building. Shortly after opening, it became apparent the Fairmont Hotel would need more rooms for the city's many guests. (Courtesy of Blackwood Associates.)

Log Cabin, Fairmont Farms, W. Va.

This cabin was built by James Otis Watson on his first coming to Fairmont about 1860. The cabin is still in use as a dwelling and is located between Fairmont Avenue and Farms Drive. The area around it is mixed use, with commercial establishments fronting Fairmont Avenue and residential homes to the east. The exterior has changed very little since it was first built, but the interior has been modernized. This is a far cry from the home James Otis would build once the Watson family fortunes were made. (Courtesy of Blackwood Associates.)

Hanging on the corner was a favorite pastime even back in the 1920s. The Woolworth store was one of three 5¢-and-10¢ stores in downtown Fairmont. The Deveny (*Dev ěny*) building was built by George Deveny, who had strong opinions about his neighbors. The uppermost floor was used by the Elks until they could build their own building. (Courtesy of Blackwood Associates.)

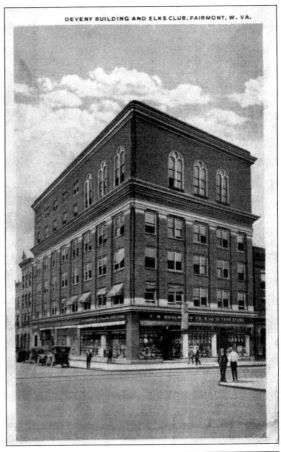

Palatine (K)nob was a high point in the Fairmont area that gave good views. Here the prosperous city of Fairmont shows off its grand architecture. Spanning the river is the Monongahela River Bridge or Million Dollar Bridge (1921). Today the span has been restored and is known as the Jefferson Street Bridge, the Million Dollar Bridge, or the Robert H. Mollohan Bridge. In the center of the picture is the Fairmont Hotel (red building at the far end and to the right of the bridge), first built in 1917 but here showing the two additional floors added in 1920. (Courtesy of Blackwood Associates.)

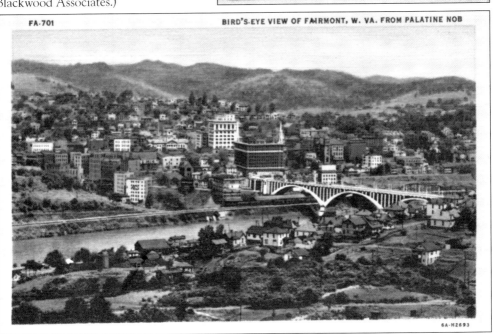

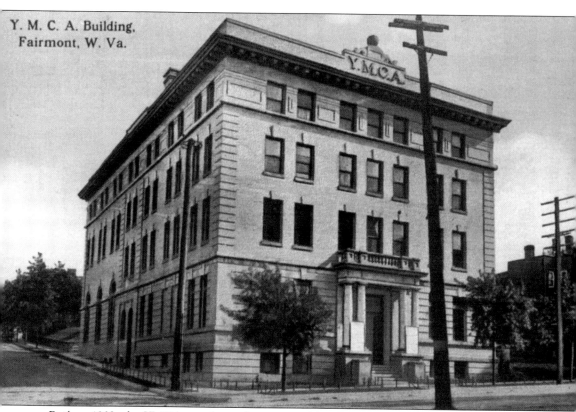

Y. M. C. A. Building,
Fairmont, W. Va.

Built *c.* 1902, the YMCA stands on the corner of Second Street and Fairmont Avenue. This chapter of the national organization had a pool, a refreshing treat in the summertime. It was a thriving affair until the Depression. Unable to meet its financial obligation, the YMCA was purchased by the Moose. Today the building stands largely vacant, being used for meetings and dances by the members of the local Moose Lodge. (Courtesy of Blackwood Associates.)

Fairmont Ave. Looking South West, Fairmont, W. Va.

This horse and buggy helps date the scene to approximately 1910. Today no evidence of this dirt surface is visible. The modern pavement sees endless streams of personal transit 24 hours a day. This area is now commercial, and no stylish houses from the era of 1892–1916 remain. Some of the homes have been refurbished as businesses and professional offices. This area is now being studied to transform it once again and give it a new identity by consciously tying it together with downtown Fairmont through design elements in the building facades and streetscape. (Courtesy of Blackwood Associates.)

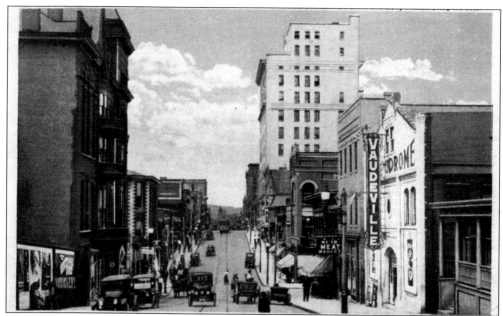

This view of Adams Street looking south from Quincy Avenue is dated *c.* 1916. Two elements of Fairmont's entertainment offerings are the Hippodrome declaring its vaudeville acts on the right side of the street and the Fairmont Theatre on the left. The city's trolley system at that time went out to Twelfth Street. The large, boxy, white building is the Watson Building. (Courtesy of Blackwood Associates.)

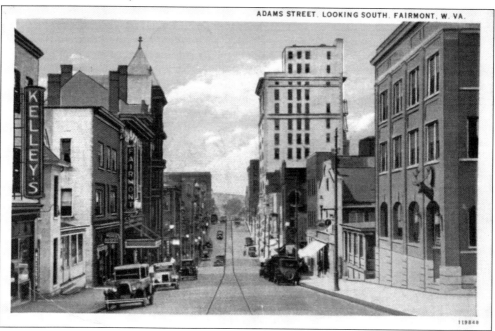

This view, while of the same area, was taken from another block up the street and shows the Elks' home on the right and Kelly's Music store on the left. The sign for the Fairmont Theatre is situated about where the current Fairmont Movie Theatre is located. (Courtesy of Blackwood Associates.)

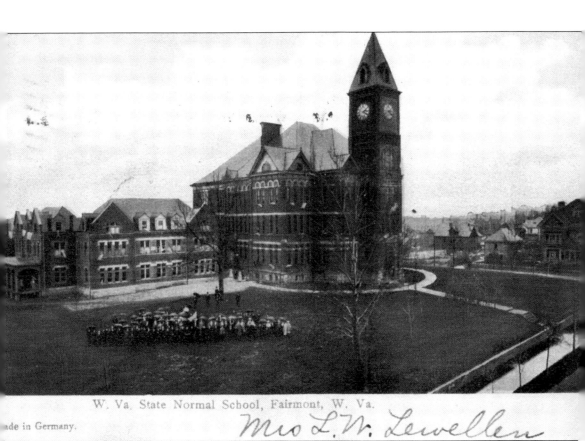

W. Va. State Normal School, Fairmont, W. Va.

ade in Germany.

Mrs L. W. Lewellen

The forerunner of Fairmont State University, the Fairmont Normal School started out on Quincy Avenue. Later, with a new name and a new complex, the Fairmont State Teacher's College stood between Third and Fourth Streets on Fairmont Avenue. Built in 1892, this edition boasted a dormitory and clock tower. By 1940, the school had relocated to Locust Avenue, and in 2006, it attained the status of a university. Today the school has a wide variety of fields of study and accommodates about 15,000 students. (Courtesy of Blackwood Associates.)

B. & O. Station and Bridge, crossing the
Monongahela River, Fairmont, W. Va.

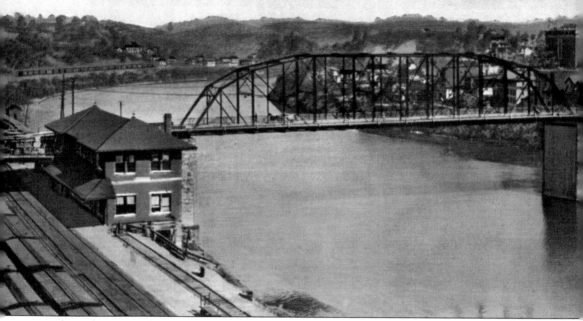

The Baltimore and Ohio Railroad came through Fairmont in 1852, completing the line from Baltimore in June of that year. The tracks were laid to Wheeling by Christmas Eve. This freight station was built shortly thereafter. The metal bridge was erected in 1908, replacing the suspension bridge which also had been built in 1852. The station was quite busy. The most unusual item to come through its doors was a 1912 Sears and Roebuck house shipped in several crates and ready to be put together. That house is still inhabited. The everyday freight was mostly farming and mining equipment. (Courtesy of Blackwood Associates.)

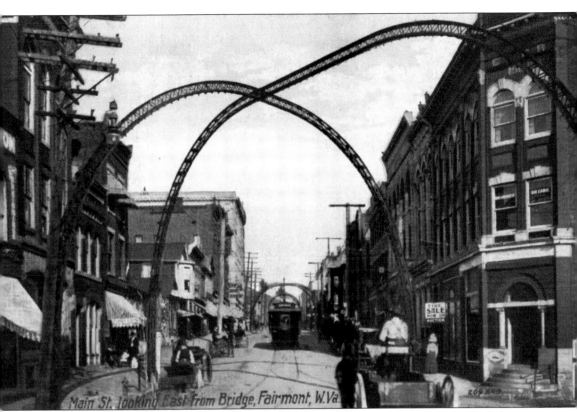

Main St. looking East from Bridge, Fairmont, W.Va.

The overarching metal framework carried the wires for the electric trolley system and had electric lights. These forms covered nine blocks on Main Street. The bridge referred to is the Southside Bridge, which connects downtown Fairmont to Fairmont Avenue after crossing Coal Run Hollow. When the town was first laid out, Boaz Fleming named the major streets after presidents (Washington, Adams, Jefferson, Madison, Monroe, Quincy, and Jackson) and the lesser after sea captains (Porter, Barney, and Decatur). Today Main Street has reverted to its original name, Adams Street. (Courtesy of Blackwood Associates.)

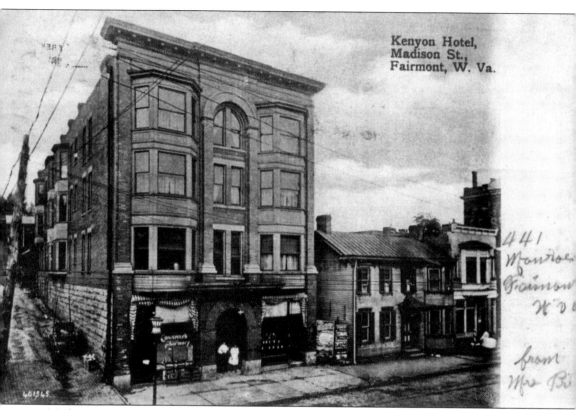

Kenyon Hotel,
Madison St.,
Fairmont, W. Va.

Madison Street runs east to west and is nearest the bottom of the hill. Conaway Pharmacy is on the ground floor in this picture, taken in the early 1900s judging by the dress of the two women in the doorway. The Kenyon Hotel was one of the small hotels that opened to accommodate men coming to town on business. It soon became clear that the number of travelers would exceed the number of hotel rooms available for them. (Courtesy of Blackwood Associates.)

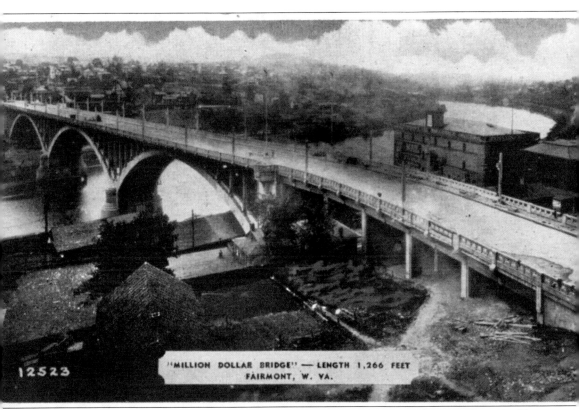

"MILLION DOLLAR BRIDGE" — LENGTH 1,266 FEET
FAIRMONT, W. VA.

12523

Originally built between 1919 and 1921, the Million Dollar Bridge opened on May 30, 1921. To celebrate its opening, crowds of people stood on the bridge in a solid mass from end to end. Leftover material from the Southside Bridge was used in constructing this one by Casey Construction of Pittsburgh. The bridge connects the area formerly known as Palatine with Fairmont. Today that area is known as the East Side. (Courtesy of Blackwood Associates.)

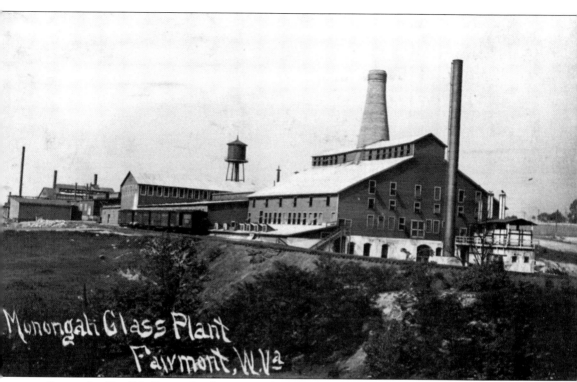

Monongah Glass Plant
Fairmont, W.Va.

Located at Twelfth Street, this factory employed men and boys in the making of glass and glass products from 1906 to 1925. Its output was shipped around the world and enjoyed a very good reputation. Named for the Monongah(ela) River, the factory was not connected with the town of Monongah or the Monongah mines. Eventually the factory was left behind by its competitors, and today no remnants remain of this major industry. At one time, it employed about 300 men and shipped railroad boxcars full of products. (Courtesy of Blackwood Associates.)

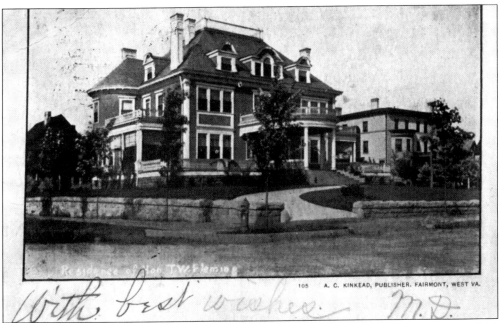

The former residence of T. W. Fleming is used today by the Women's Club of Fairmont. Built *c.* 1915, the home sports a portico with a balcony, two side porches, and at least four chimneys. It also has the first elevator in Fairmont, and it is in working order. (Courtesy of Blackwood Associates.)

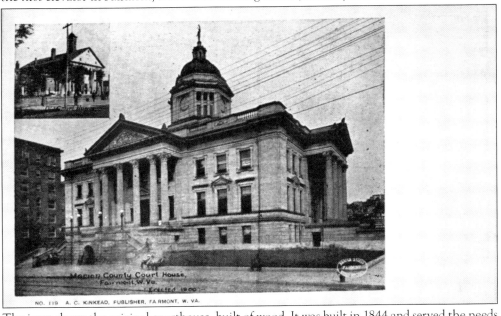

The inset shows the original courthouse, built of wood. It was built in 1844 and served the needs of the county for 53 years. In 1897, it was torn down and replaced with a much larger structure. When men of the city learned of delays in tearing down the previous building, they took it upon themselves to help out. Working overnight, they had the building torn down past the point of no return, forcing the project to go forward. The new building was opened in early 1900. Its neoclassical style, cupola, and Lady Liberty echo some touches of Monticello and the White House. (Courtesy of Blackwood Associates.)

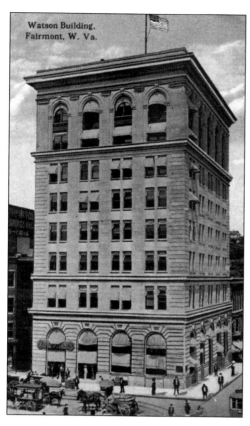

Watson Building,
Fairmont, W. Va.

The Watson Building was begun in 1909 on the former site of the First Presbyterian Church. The church's attendant graveyard had been excavated and the remains moved to Woodlawn in 1878 or 1879. The new building would house the offices of the various concerns of the Watson family (coal, gas, oil, real estate, and banking). Completed in 1911, this building houses WesBanco along with other offices. (Courtesy of Blackwood Associates.)

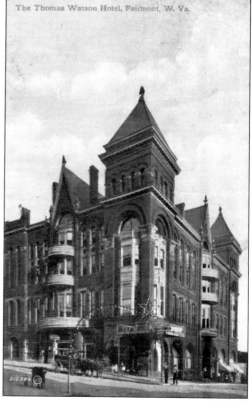

The Thomas Watson Hotel, Fairmont, W. Va.

Built in 1894 on the corner of Adams and Madison Streets, the Thomas Watson Hotel changed hands frequently during its 62 years of operation. The lower floor was let out to businesses and the upper floors to sleeping rooms and dancing rooms. The architectural firm Leiner and Faris of Wheeling designed the building, John Doheny excavated the site, and a Mr. McClaine constructed the building. The metal arch with lights dates this picture to early in the 1900s, as the apparatus was used for the trolley line. (Courtesy of Blackwood Associates.)

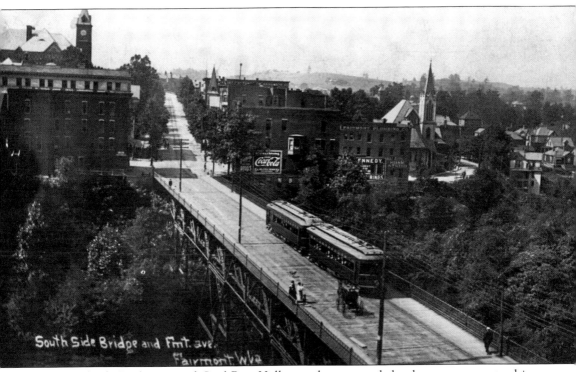

The Southside Bridge crossed Coal Run Hollow and connected the downtown area to this neighborhood along Fairmont Avenue. The bridge accommodated not only trolleys, but also horse and buggies as well as foot traffic. Today the bridge carries only automobile traffic. This area is mixed use, with businesses, churches, and residential homes. A group is studying the area and making plans to create a coherent streetscape that will blend more easily with the downtown business district. (Courtesy of Blackwood Associates.)

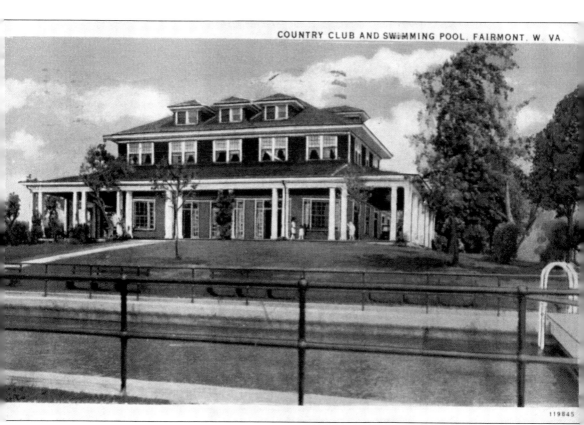

The Fairmont Field Club was incorporated in 1911, and the clubhouse was completed in 1912. Its first president was A. Brooks Fleming Jr., son of A. B. Fleming, the eighth governor of West Virginia. Its stated purpose was entertaining and contributing to women's literary knowledge. The club sponsored book clubs and similar activities for the ladies. The nine-hole golf course has a unique feature—each hole is played twice, from two different teeing-off places. The pool pictured in the foreground was in use from 1922 to the early 1960s, when a newer pool was built and this one filled in. Tennis courts round out the club's recreation facilities. The clubhouse can be used for banquets, weddings, dances, and other social occasions, as well as having a tavern and restaurant on the premises. (Courtesy of Blackwood Associates.)

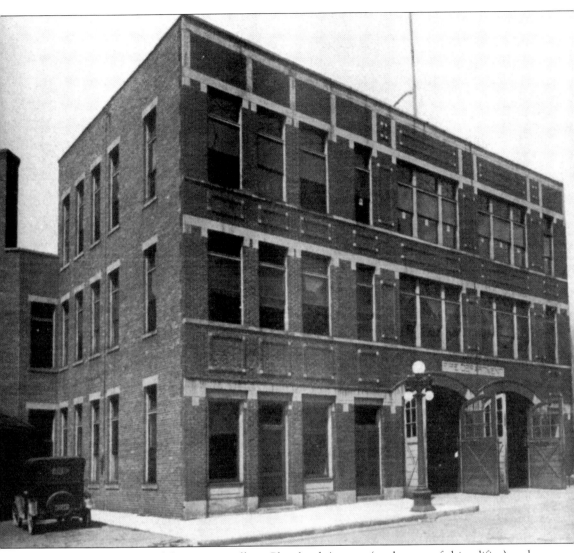

The City Building stood four stories tall on Cleveland Avenue (to the rear of this edifice) and three on Monroe Street. Here were housed all offices of the city government as well as the city jail. The Central Fire Station was located here, where the double set of arched doors are open. Both the fire department and police department remained in this building until a new structure was completed in the fall of 2006. These departments are now located on Quincy Avenue in a former department store that was refitted to meet the safety needs of the public. The other city and county offices had been relocated to the Harper Meredith Building on Jackson Street in the 1960s. (Photograph courtesy of the *Report of the Several Departments under Commission form of Government, Fairmont, WV: from January 1st, 1914 to July 1st, 1919.*)

In 1919, Fairmont boasted of its sanitary department, which came into existence during the five years of this government's tenure. Outdoor water closets, garbage- and debris-strewn hillsides, dumps, and horse manure all contributed to an odorous and unhealthy environment. Flies were virtually eliminated from Fairmont due to the efforts of the Woman's Club, and the work of the men pictured did much to improve things. Ed Williams, Lacy Hawkins, James Glover, John Fulton, and John Maxwell are pictured above with the department's vehicles. (Photograph courtesy of the *Report of the Several Departments under Commission form of Government, Fairmont, WV: from January 1st, 1914 to July 1st, 1919*.)

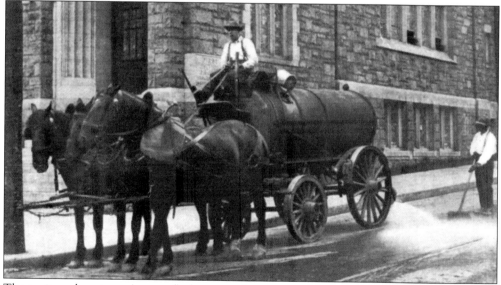

The sanitary department's street flusher was a forerunner of the road-cleaning equipment in use today. Water is dispensed from a tank mounted on wheels and drawn by three horses, which are probably not the only horses in town. A man walks behind to sweep the debris to the curbside to aid in the cleaning of the streets. Notice that the streets are brick. This picture was taken in front of the First Presbyterian Church in downtown Fairmont. (Photograph courtesy of the *Report of the Several Departments under Commission form of Government, Fairmont, WV: from January 1st, 1914 to July 1st, 1919*.)

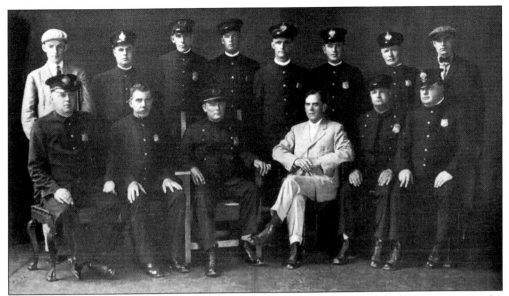

Police chief Fred S. Harr and assistant chief Albert H. Seaman are backed by the men on the force. Desk sergeant M. J. Deveny, traffic officer Howard Woodward (on the right back row in the pork-pie hat), and patrolmen A. N. Fleming (seated on the front row far right), J. B. Boggess, W. A. Digman, Tom Ford, C. L. Holt, Howard Nuzum, L. E. Eakle, and Art Kern. In 1919, the men worked 12-hour shifts, seven on the night shift and five during the day. (Photograph courtesy of the *Report of the Several Departments under Commission form of Government, Fairmont, WV: from January 1st, 1914 to July 1st, 1919*.)

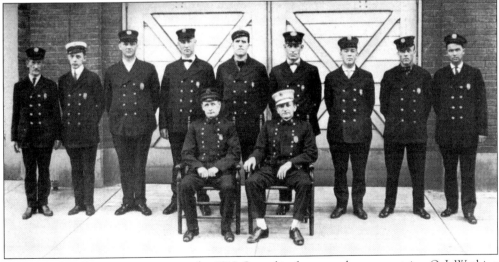

Fairmont's Fire Department is pictured c. 1919. Seated in front are the two captains, O. J. Watkins and O. J. Shaw. Ranged behind them are the professional firefighters: assistant chief R. F. Doolittle, W. F. Clayton, Fleming Hamilton, E. L. Kelly, Lester Sherrard, John Radcliff, William Morgan, Andy Vandergriff, and Hosea DeBerry. The company grew from a half-dozen volunteer firemen with a small reel hose around the beginning of the 20th century; a man and one horse were added on the East Side. Three men and two horses made up the Central Station. Later a hook and ladder wagon was added. (Photograph courtesy of the *Report of the Several Departments under Commission form of Government, Fairmont, WV: from January 1st, 1914 to July 1st, 1919*.)

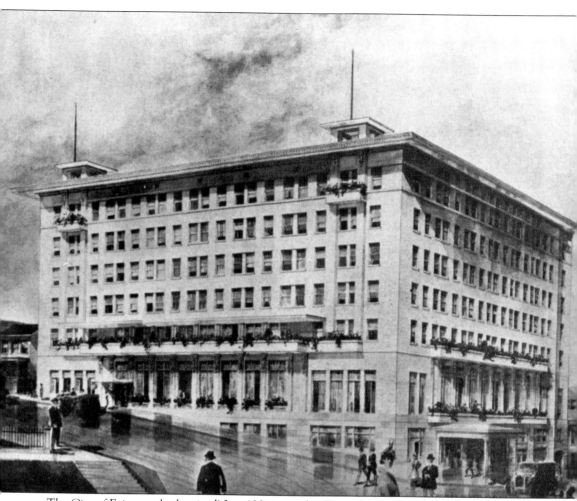

The City of Fairmont had arrived! Just 100 years after Boaz Fleming laid out and parceled off his lots, a modern, world-class hotel was needed to accommodate all of the people coming to town. The Fairmont Hotel was built in 1917 and added two floors in 1920. Located near the Baltimore and Ohio station and the Million Dollar Bridge, it was filled to capacity for most of the year. It also featured a nightclub in its basement. In 1984, the site was turned into the East View apartments. (Courtesy of the Marion County Historical Society.)

The eastern shore of the Monongahela River in what is now East Side was first settled by the Haymonds and Polsleys. Jacob Polsley built a woolen mill along the river, and his home was on the east bank. It was built in 1793. Jacob Polsley was a veteran of the Revolutionary War. His grave is in Maple Grove Cemetery. This cemetery began as the Haymond family cemetery. (Photograph taken by the author.)

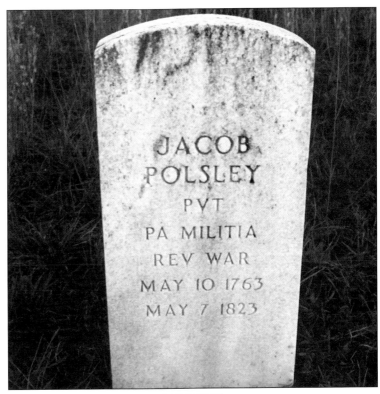

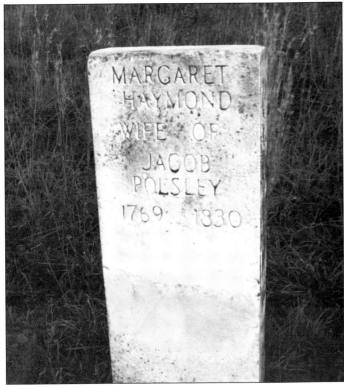

The daughter of William Haymond Jr., Margaret Haymond Polsley was the love interest of two men: Jacob Polsley and Albert Gallatin. Gallatin was secretary of the U.S. Treasury (1801–1814) and a friend of Jacob. He later became the U.S. ambassador to France. It is said that Albert asked his friend Jacob to woo Margaret Haymond on his behalf—Margaret married Jacob instead of Albert. Margaret was a witness to the birth of a small town in western Virginia as the wife of a miller. She could have witnessed the birth of a nation. (Photograph taken by the author.)

Maj. William L. Haymond and his son were surveyors. William Sr. helped Boaz Fleming lay out Middletown. His son laid out the small town known as Palatine in 1839. It was named due to a group of German emigrants from the Palatine region of Germany living there. In 1899, the area was joined with Fairmont and chartered as a city. (Photograph taken by the author.)

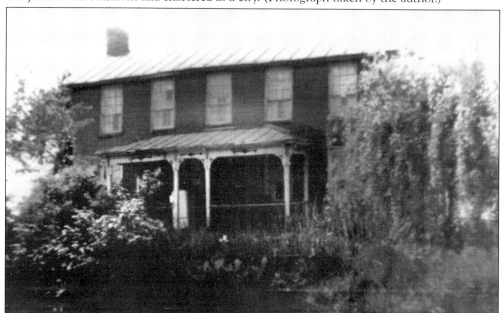

This is the home of William Haymond, built near Palatine Knob in 1794. A post office was established here and was contained within an early American secretary desk. William Haymond Jr. was the first postmaster. Julia Augusta Robertson was employed as a governess for the Haymond children and met Frank Pierpont at this home as well. The home was destroyed in 1995. (Photograph courtesy of the Marion County Historical Society.)

Seven

FOR DEAD I
WELL MAY BE

The ways in which we choose to remember our loved ones vary from culture to culture. As we change our dress, homes, cars, and hair, we also change the stones and the symbols with which we mark the passing of a loved one. Over time, as stones became less expensive to quarry and engraving became more technologically advanced, our choice of gravestones became more diverse. Marble, sandstone, slate, and granite tend to be the types of stone most often used. In addition to carving the name and dates of an individual's life, the stone also tells us something about the person. Religion, occupation, fraternal societies, family connection, and iconic symbolism can be read on the surface of a stone.

This style of simple stone incised with a first name and the date of death and age is quite common in the small family plots found throughout West Virginia. This stone belongs to Mary Fleming and is located in the Nathan Fleming cemetery on Locust Avenue. Mary accompanied her husband from Delaware in 1788 and died at the age of 70 in 1815. (Photograph taken by the author.)

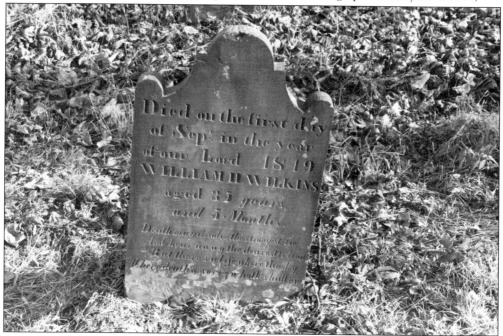

This stone is cut in the Colonial style. Its form is known as tympanum for the top-center form of the stone. The stone itself is sandstone. Early in the 19th century, sandstone was more easy to come by and more easily carved. (Photograph taken by the author.)

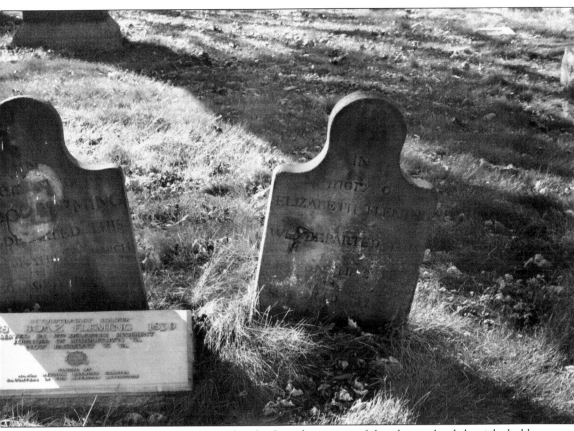

Elizabeth Fleming's stone has a discoid arch. On other stones of this shape, the disk might hold a symbolic carving of a weeping willow, a winged death's head, or an hourglass. As technology advanced in the business of quarrying stone, different types of stone became more available and more affordable. (Photograph taken by the author.)

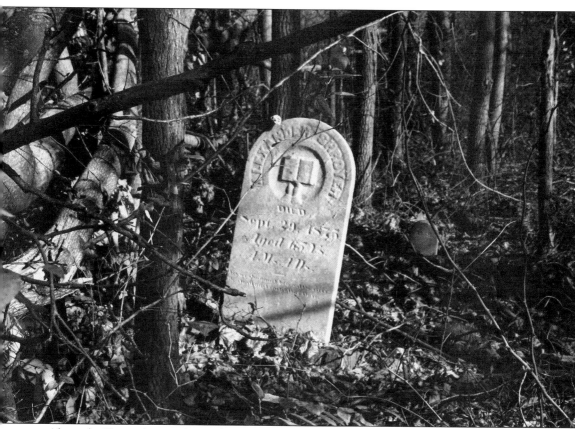

Alexander Shroyer's stone shows a hand holding an open book. This usually represents the book of life, although it is sometimes the Bible. Alexander is buried beside his wife, Molly. Unfortunately, during a recent storm, a tree fell on Molly's stone, breaking it off at the base. It is the hope of one of Alexander's descendents to travel here to remove the tree and repair the stone so that it is not lost. Other members of the Shroyer family are buried in Woodlawn Cemetery. (Photograph taken by the author.)

This stone tells us the symbol is the book of life. The stone has been carved to duplicate the look of a closed book. (Photograph taken by the author.)

The open book on the top of this stone says simply "At Rest." William Monroe Dunnington was a carpenter in life. Notice also the drapery. (Photograph taken by the author.)

This draped funeral urn is on the top of the stone, while an open book can be seen at the lower end of the stone. These images are quite common on stones from this period. (Photographs taken by the author.)

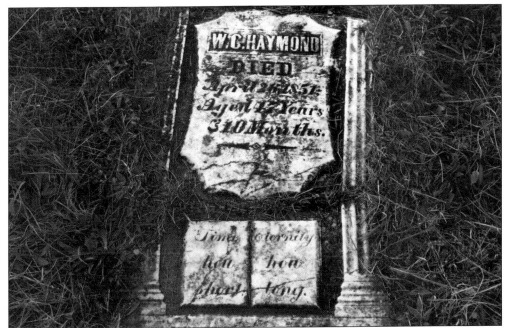

Some stones attest to the skill of the carver. This ornate stone has Ionic columns on either side of an open book, with a shield suspended between them holding the individual's name and life dates. William Haymond died the same year as his father, although he was 30 years younger. (Photograph taken by the author.)

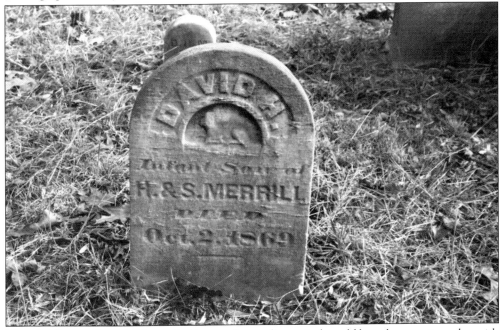

This child's stone has a basket arch. Stones of an earlier period would have been rectangular, with at least as much of the stone underground as above it. The squared-off edges became softened when the technology for quarrying stone and transporting it were advanced. (Photograph taken by the author.)

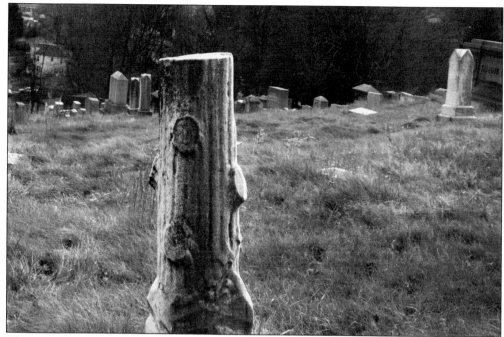

This stone is made to look like the stump of a tree. This symbol can denote a life cut short. Tree stumps or logs modeled from stone are also common markers for members of Woodsmen of the World. One of the benefits of membership was a grave marker. (Photograph taken by the author.)

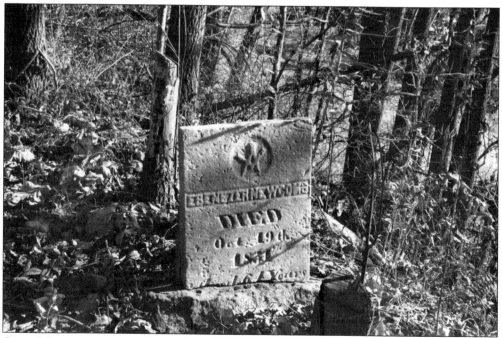

One of the most common fraternal organizations found on gravestones is the Masons in their the various degrees. Ebenezer Newcomb may have also owned the first store in Middletown (Fairmont). (Photograph taken by the author.)

The curved sword, half moon, and suspended Maltese cross are more common today. They depict this individual's membership in the Shriners. (Photograph taken by the author.)

This capped column is of rose-colored marble. Imported Italian marble became more affordable as the century progressed and began to show up on more grave sites. Woodlawn Cemetery changed its policy about the stone monuments it would allow to be set. A good grade of polished granite was required by the 1930s. (Photograph taken by the author.)

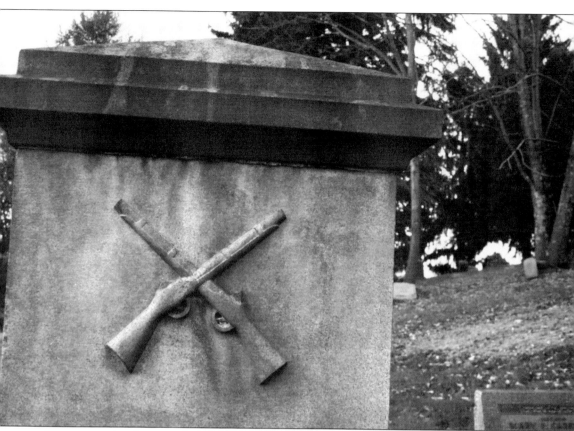

These crossed carbines mark the grave of a former soldier. The make and caliber of the armament gives us clues about the war in which he fought. This stone is in the Maple Grove Cemetery. (Photograph taken by the author.)

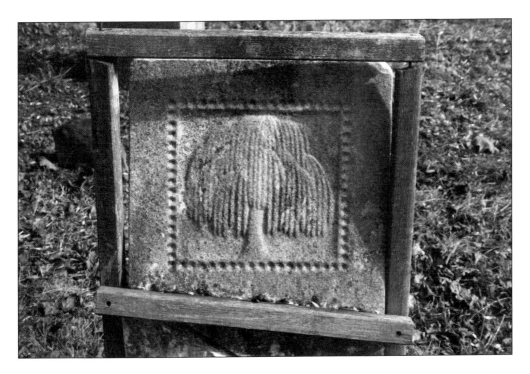

A universal symbol of grief is the weeping willow. The photograph above is a more realistic rendering. The one below is more stylized. The wooden framing of the first stone is meant to hold the broken stone together. With care and the proper adhesives, this stone can be repaired. (Photograph taken by the author.)

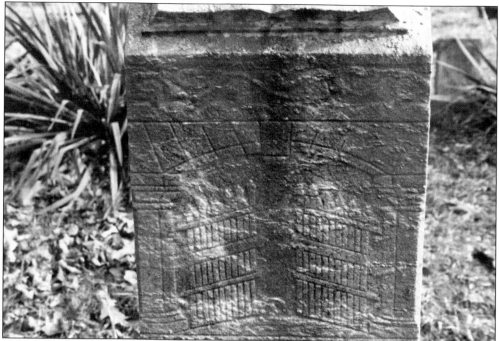

This stone depicts the gates of heaven standing open for the soul of the departed to enter. As tools became more specialized and stonecutters more plentiful, the symbols on the gravestones became more elaborate. (Photograph taken by the author.)

The winged angel is a common symbol on children's stones. Lambs are also common on children's stones. (Photograph taken by the author.)

The Woodsmen of the World is a fraternal organization that supplies its members with headstones. They are usually depicted as logs or trees. (Photograph taken by the author.)

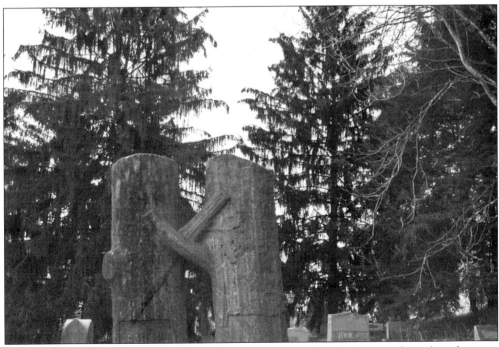

These two trees seem to be holding branches. A husband and wife choose to show their devotion even after death. (Photograph taken by the author.)

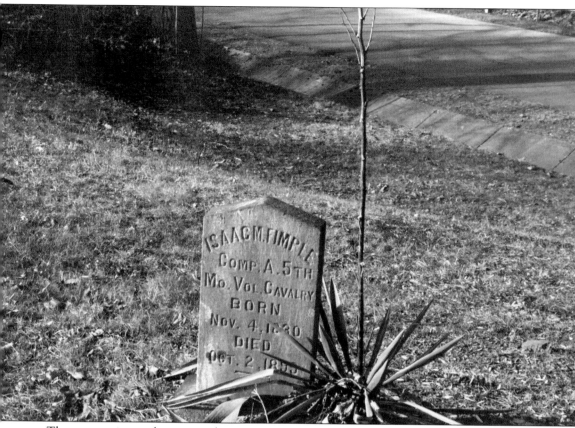

The message is not always carved in stone. Sometimes the plantings found in a cemetery have a traditional meaning and have been specifically placed there. The yucca is a traditional plant in cemeteries. It is an evergreen and has come to symbolize eternal life. Its suitability lies in its slow growth and ability to adapt. It was used to mark either the head or foot of a grave. (Photograph taken by the author.)

Eight

You'll Come and Find the Place Where I Am Lying

People move from one place to another in search of some unknown something that just seems to have been missing where they were. In Fairmont's case, the pioneers who settled the area began to dream of something more than their farms and their families. Boaz Fleming began to dream of a town and worked to make it happen. He also wanted a new county formed. He was tired of having to drive a horse and wagon to both Morgantown in Monongalia County and Clarksburg in Harrison County to pay taxes on property the family held in both counties. He would not live to see the formation of Marion County (1842) or make the journey of 20 minutes to Morgantown and 30 minutes to Clarksburg today. His descendants began to build their own dreams. Families, businesses, industries, financial houses, places of worship, entertainment, socialization, governance, and law and order were all areas that had to be fashioned, planned, built and improved upon to give rise to Fairmont, Marion County, West Virginia, in the United States of America.

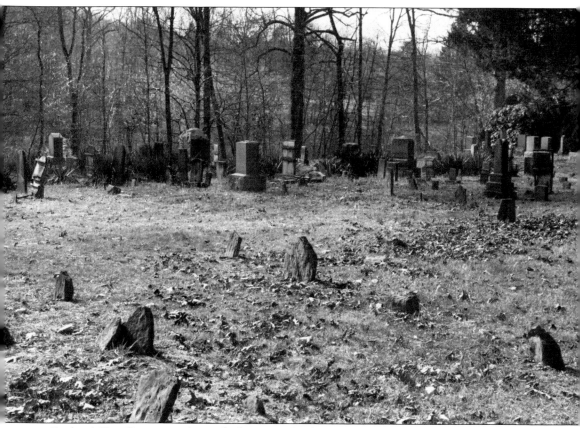

Prickett's Fort Cemetery is located adjacent to Prickett's Fort State Park. It is to the right on the main road leading into the park. It holds not only the remains of early settlers, but of some of their contemporary descendants as well. The fort was built as a place of safety for these early settlers. They would gather within its walls when danger was near. (Photograph taken by the author.)

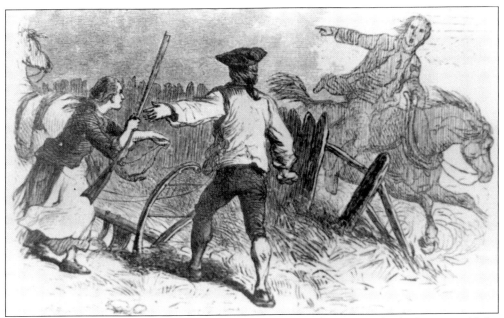

This pen-and-ink drawing depicts the spread of the alarm. The mounted rider has just told the farmer that danger is near. His wife hurries to him carrying his powder horn and long rifle. (Courtesy of Prickett's Fort.)

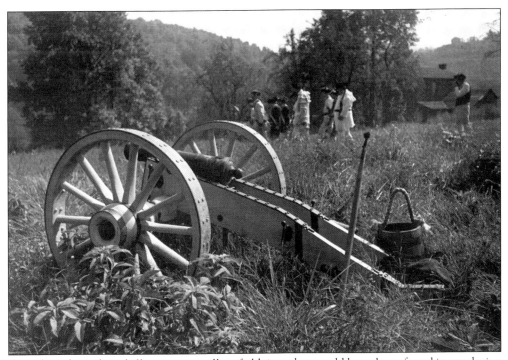

A modern-day militia drills near an artillery fieldpiece that would have been found in use during the Revolutionary War. (Courtesy of Prickett's Fort.)

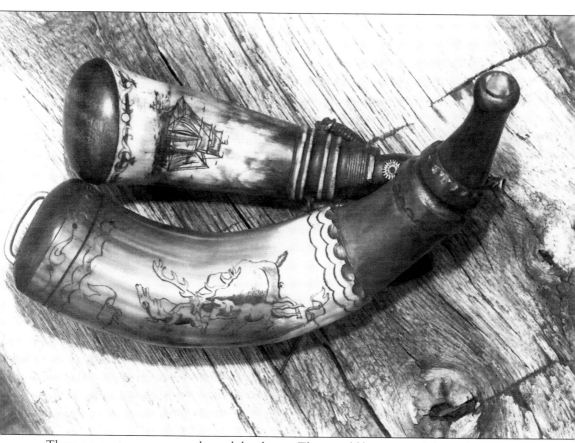

These are contemporary powder and shot horns. They would have carried the tools necessary to protect the homes of early settlers. (Courtesy Prickett's Fort.)

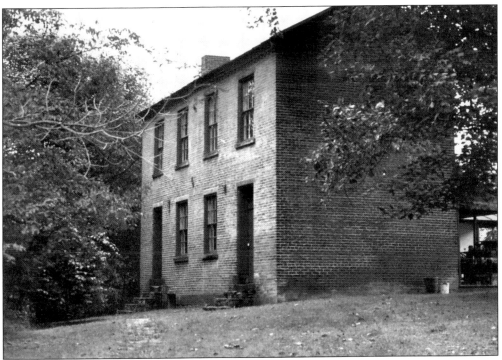

This house is that of Job Prickett and dates from the Civil War. It has been restored and is open for tours during part of the year. (Courtesy of Prickett's Fort.)

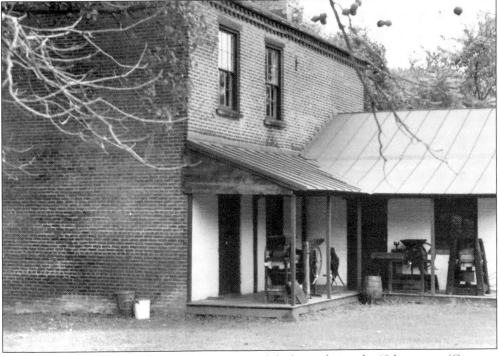

The porch area holds some of the tools in use around the home during the 19th century. (Courtesy of Prickett's Fort.)

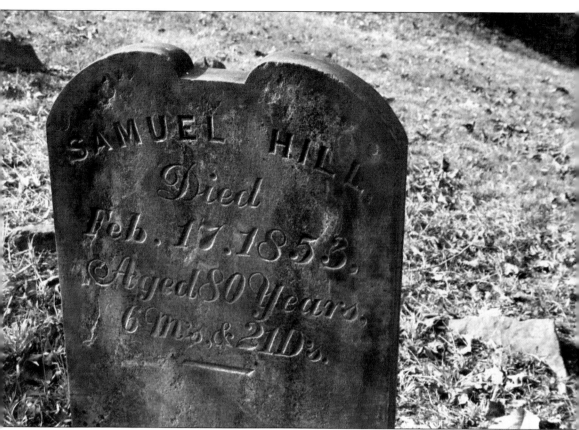

Eighty years was a long life for the mid-19th century. At a time and place fraught with danger, this individual was probably a hearty soul. How many of his descendants can boast a similar feat? (Photograph taken by the author.)

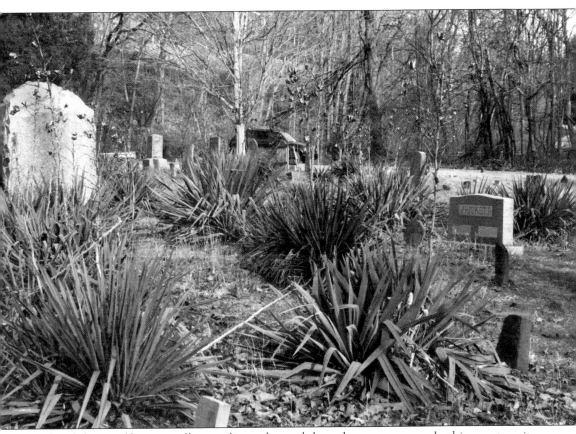

When left to itself, yucca will naturalize and spread throughout a cemetery. In this cemetery, it seems to have very little competition for space. (Photograph taken by the author.)

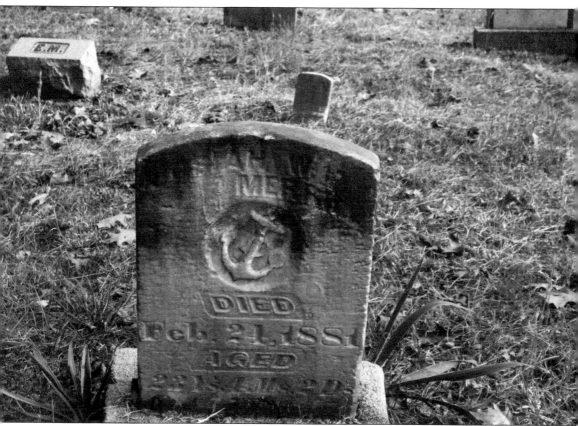

Josiah W. Merrill was only 22 years old. The anchor on his gravestone was an early Christian symbol denoting safety. The bar across the top of the anchor's stem is taken as another form of the familiar Christian cross. (Photograph taken by the author.)

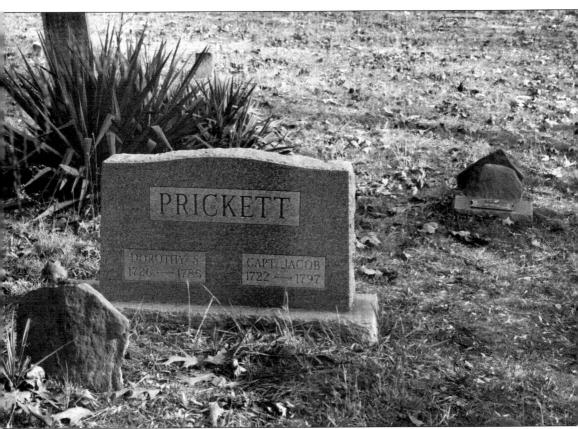

This contemporary stone is set for Capt. Jacob Prickett and his wife. Although his grave is unmarked, another revolutionary veteran is buried here. John Champe undertook to capture Benedict Arnold at the behest of George Washington. He made it look as if he were deserting the Continental Army and went over to the English side. Although his mission was unsuccessful, Champe completed his enlistment and died near Prickett's Creek while visiting and is buried here. (Photograph taken by the author.)

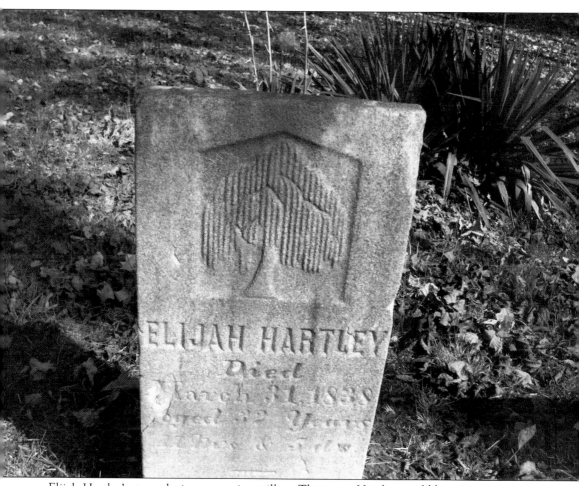

Elijah Hartley's stone depicts a weeping willow. The name Hartley would become synonymous with upscale shopping in Fairmont in the late 19th century. (Photograph taken by the author.)

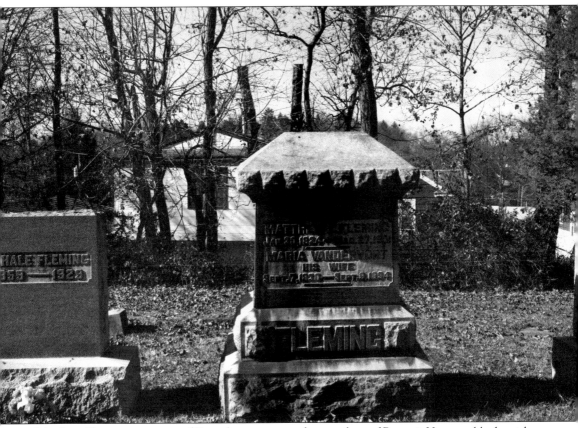

Matthew Fleming was a son of Boaz the younger and a grandson of Benoni. He was a blacksmith and farmer and owned a brickyard. His daughter, Anna Belle, married William Kelly and is also buried here, as is his son, Ulysses. (Photograph taken by the author.)

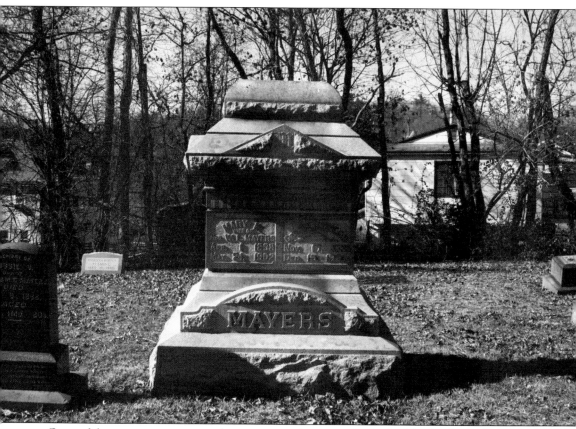

George Mayers was a carpenter who went on to become a bridge builder for the Baltimore and Ohio Railroad. He was also a contractor and built many of the homes of the distinguished in Fairmont. His sister, Jennie, married Benjamin D. Fleming, a prosperous dairy farmer and a founder of the First National Bank. (Photograph taken by the author.)

Ulysses Sydney Fleming was born on August 20, 1851. He was the oldest son of Matthew Fleming, who was the oldest son of Boaz Fleming (the older Boaz's nephew), who was the oldest son of Benoni Fleming. He was made principal of the Fairmont Normal School in 1905 and died on October 23, 1912, one day after his 33rd wedding anniversary. The lower photograph is the stone that marks his grave in the Benoni Fleming cemetery. He is buried not far from his father. (Right courtesy of the Marion County Historical Society; below photograph taken by the author.)

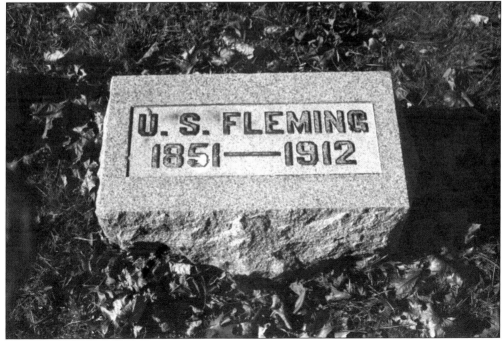

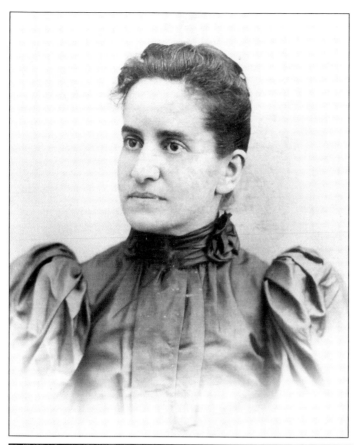

Ella May Heavner married Ulysses on October 22, 1879. She was the daughter of B. L. Heavner. She and Ulysses had six children, five girls and one boy. The children are Lora Marie, Alice Hunnings, Minnie Persis, Mabel Leona, Elsie Juanita, Virginia Lee, and Paul Vandervort. Ella May died on January 12, 1923. The photograph below shows her stone. She lies in the Benoni Fleming cemetery beside her husband. (Left courtesy of the Marion County Historical Society; below photograph taken by author.)

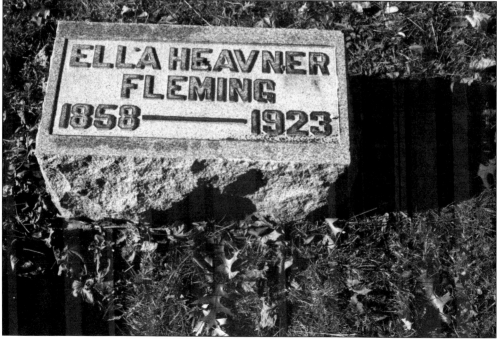

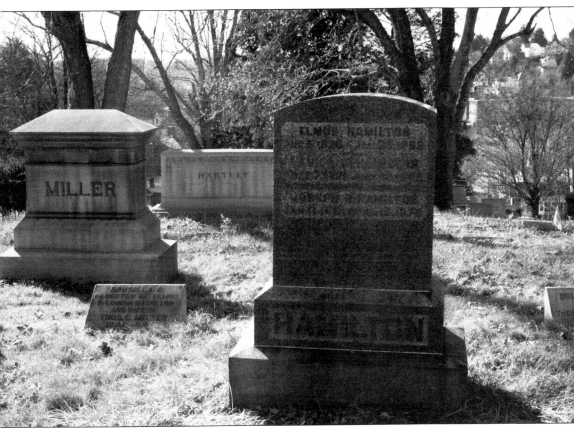

Elmus Hamilton owned the farm on which Woodlawn Cemetery came to be. His son, Joseph, was the first to be buried here. Elmus is the son of Clarissa Fleming and James Hamilton. His son-in-law, Thomas Condit Miller, is buried behind him. Miller was a professor at West Virginia University in its early days and was a respected educator. Miller Junior High School in Fairmont was named for him. (Photograph taken by the author.)

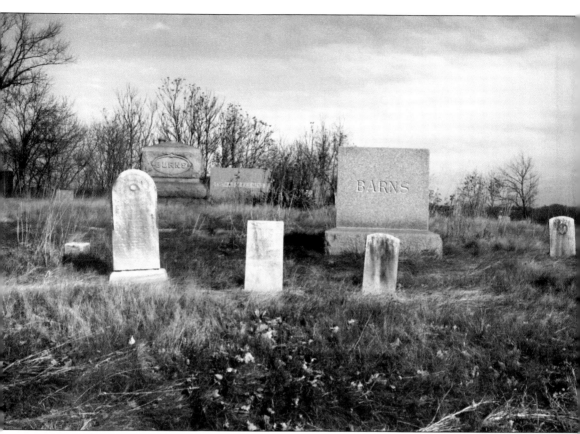

Across the fence is the Barns family. They owned the adjoining farm. At Joseph Richey Hamilton's death, the fence between the two farms was opened and a family graveyard was established. The Barns family became prominent with the founding of Barnesville (today Belleview) and woolen mills. Some of these stones predate the cemetery, as remains were removed from other places and reinterred here. (Photograph taken by the author.)

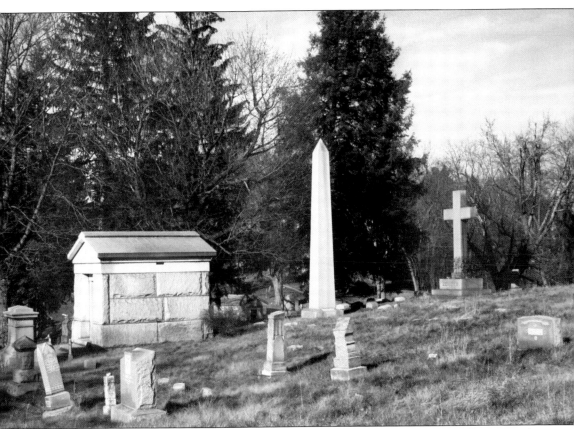

These three large monuments belong to three men who were instrumental in the early success of Fairmont and West Virginia. The blocky mausoleum in the front left holds Sylvanus Lamb Watson. The obelisk belongs to A. B. Fleming, a governor of West Virginia, and the large cross belongs to James Edwin Watson, of importance in the coal industry. (Photograph taken by the author.)

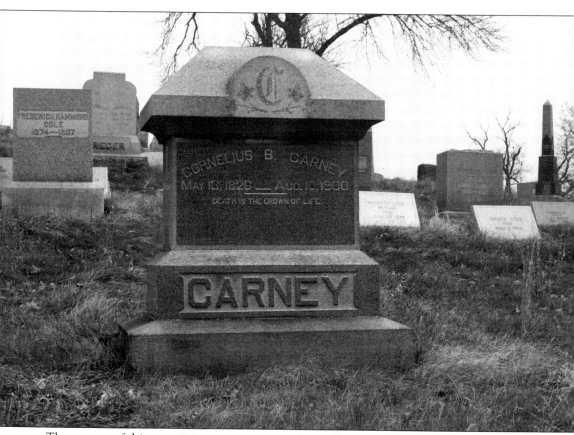

The expense of this stone is in great contrast to those of his parents, Michael and Mary Carney. Cornelius was a successful businessman and had been sheriff for one term beginning in 1880. While his stone is in Woodlawn, his parents, a brother, and a niece are in the City Cemetery, about five blocks down the street. Other members of his family are buried in Woodlawn or are in the abbey at the crown of the hill. (Photograph taken by the author.)

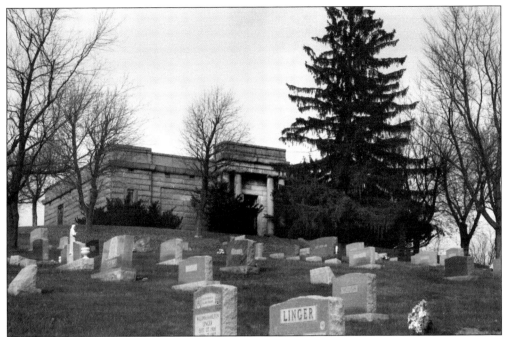

Woodlawn Abbey crowns the hill at Woodlawn Cemetery. This 500-crypt mausoleum is neoclassical in design and has several stained-glass windows. The abbey is in need of repair if it is to stand testament to the accomplishments gained by those interred there. (Photograph taken by the author.)

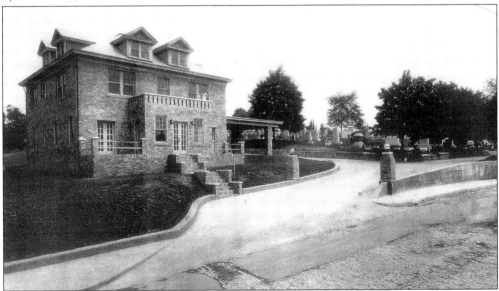

The chapel and caretaker's residence are located just inside the front entrance to Woodlawn Cemetery. Built in 1928–1929 with Hammond firebrick manufactured locally, the building was completed due to the generosity of the plumbers, electricians, and other tradesmen who donated either the material or the labor to complete the project. The building has fallen out of use and is in bad need of restoration. It is the hope of the cemetery's board of trustees that this building can be saved and put to adaptive reuse in the near future. (Courtesy of Diane Hutchinson Parker.)

This stone for Dr. William Stevenson was first discovered lying on its back. The stone was not easily read except for the name. A light snow, however, filled the crevices, and the epitaph could be made out. "Far from his home Among strangers he sleeps But Christ the Lord has Sanctified his rest." Dr. Stevenson had succumbed to the disease he had been in Fairmont to treat. (Photograph taken by the author.)

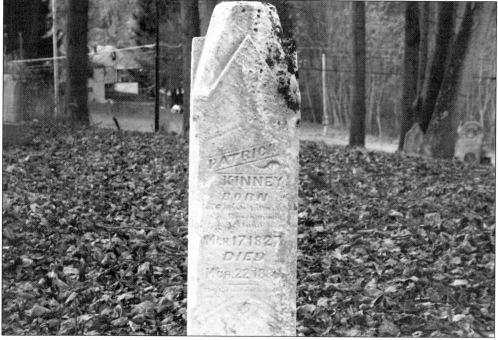

Patrick Kinney is buried beside his son, Michael. Each of their stones had to be recovered and placed upright on their bases. Patrick was an Irish immigrant, but his son Michael was born in America. (Photograph taken by the author.)